A His Camaradas.
Amis, Camarades.
Among Comrades.

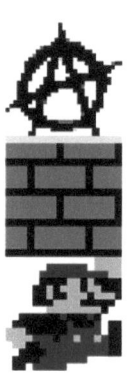

"Minimum Wage / Maximum Score"

A Book of Propaganda

by

Txema Novelo

Book 1: The Right to Eden.

The Game is Over: Time for UTOPIA

Mexico City
Yautepec Gallery
2010

Melchor Ocampo # 154-A, Col. San Rafael.

(Ne Travaille Jamais)

"A Sane Revolution"
by
D.H. Lawrence

If you make a Revolution, make it for Fun,
don't make it in Ghastly Seriousness,
don't do it in Deadly Earnest,
do it for Fun.

Don't do it because you Hate People,
do it just to Spit in their Eye.

Don't do it for the Money,
do it and be damned to the Money.

Don't do it for Equality,
do it because we've got too much Equality
and it would be Fun to upset the Apple-cart
and see which way the Apples would go A-rolling.

Don't do it for the Working Classes.
Do it so that we can all of us
be little Aristocracies on our own
and kick our heels like jolly escaped Asses.

Don't do it, anyhow, for International Labour.
Labour is the one thing a man has had too much of.
Let's abolish Labour, let's have done with Labouring!

Work can be Fun, and men can enjoy it;
Then it's not Labour.
Let's have it so! Let's make a revolution for Fun!

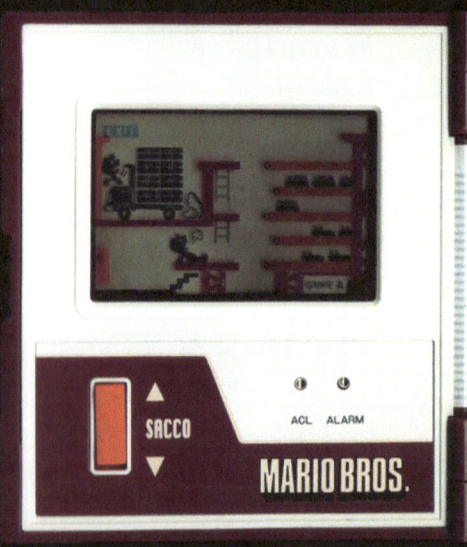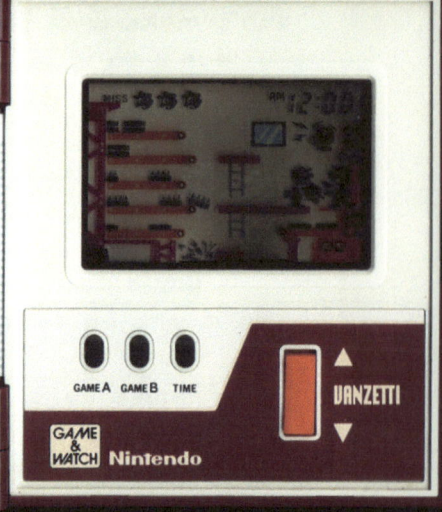

LET'S FIGHT
THE ANTIFASCIST ELECTRONIC GAME

DBM
Darth Baader Meinhof

"Einsturzende Neu Bauten"

An Anti Imperialist Terrorist Attack Perpetuated at the SONY MEDIA ISLAND in Second Life

by

Txema Novelo

(Disguised as a Second Life Herald Journalist)

The Game is Over: Time for UTOPIA

Second Life
(In World)
2006

http://secondlife.com

← Just in time for Herald 3rd Birthday: Lost Daily Show Episode Discovered! | Main

October 24, 2006

Sony Media Monorail Derailed!

Plywood pileup - lone devolutionist claims responsibility

by Txema Nuvolari

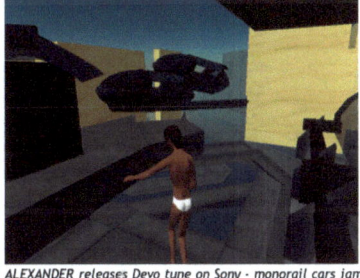

ALEXANDER releases Devo tune on Sony - monorail cars jam

On the night of Sunday October 22th 2006, Monorail transportation on Sony´s Media Island was artistically sabotaged by an avatar who´s identity will be presented here as "Alexander".

By building up huge wooden boxes, Alexander started to block the monorail´s tracks, until the point were two of the constantly circulating vehicles were stuck - one over the other. Alexander also blocked entry to several entrances for some of the island attractions.

Being in the right place at the right time allowed the Herald to ask a few questions on the motives of this creative political act from this Artist - a ground breaking new talent here at the beginning of the millennium - now using as creative canvas a whole new virtual world.

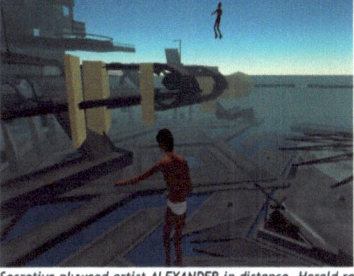

Secretive plywood artist ALEXANDER in distance, Herald reporter in underwear in forgeround

Txema Nuvolari: Alex what are your motifs for this series of constructions?

ALEXANDER: I am all against the progression of societies by their
constant need of build, edificate and create, since the bible humans
use building as a mirror of effort and progression over god's content,
this is definately my primary focus, the possible
obstruction/demolition of new architectures, as an act of devolution.

Txema Nuvolari: Are you part of any group, collective or resistance front?

ALEXANDER: No, at all, this is something I do by myself.

Txema Nuvolari: So you mention the sabotage over New architectures.
this is a not so new concept, born mainly by the german avant-garde
band Einsturzende Neubauten, from the late 80's and not going that
far, it is also something that Andrew Kevin Walker sort of exploited
in the end of his celebrated book, "The Fight Club". Do you consider any
of these possible influences?

ALEXANDER: Well, fuck fight club, and about Einsturzende, the only
decent work they have is Blixa Bargeld´s Poetry, besides that my
influences are mainly Baudelaire's Artificial Paradise, and I guess
for just fucking around places, you really don´t need that much
influences, just some spare time and will to destroy, I have a lot of
both.

Txema Nuvolari: Thanx, I think your work is awesome.

ALEXANDER: then shut up and give me a hand.

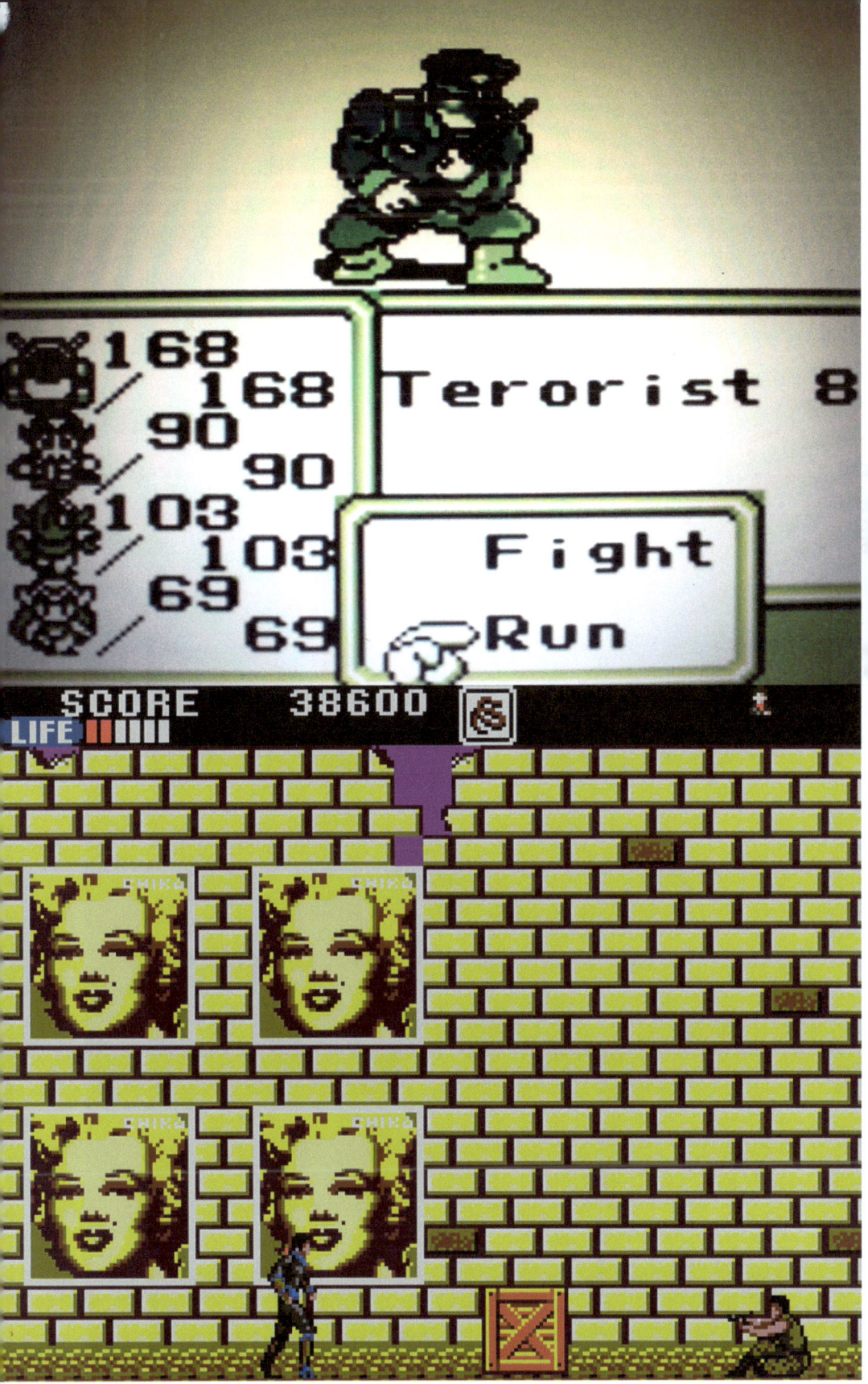

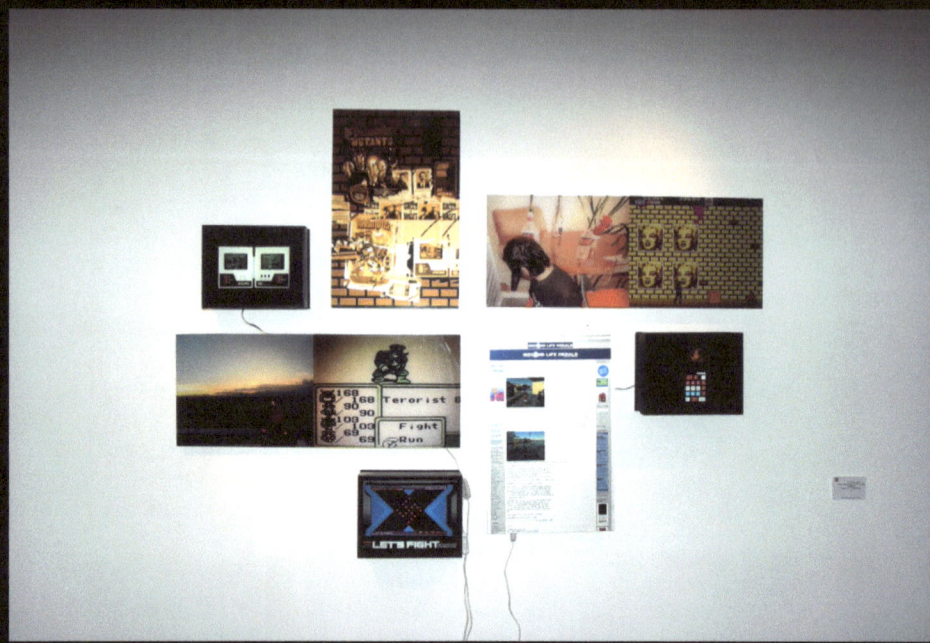

MINIMUM WAGE / MAXIMUM SCORE & ESCAPE IS NO RETURN
Mixed Media & Vinyl
Txema Novelo © 2002 - 2008

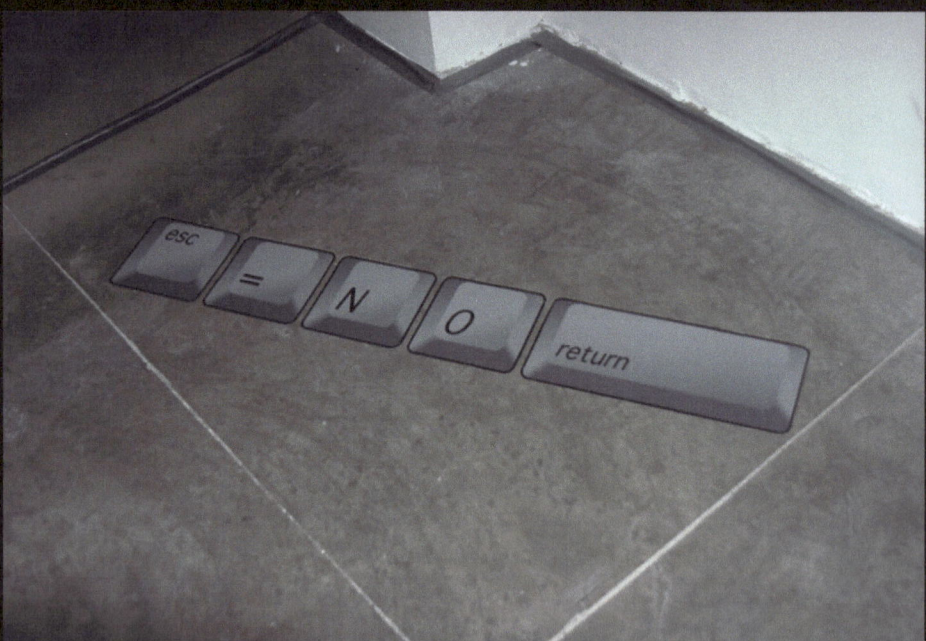

GAME OVER
Emilia Cohen Arte Contemporaneo
Center of Art & Design CAD, Juan Vázquez de Mella # 481, Polanco, México City.
April 21, 2008

Artists: Yohanna M. Roa / Fabián Ugalde / Alvaro Castillo / Sandra del Pilar / Leomar / Luis Re Txema Novelo / Raymundo Sesma / Maru de la Garza / Jens Kull / Joaquín Segura / Sarah Minter / Alonso Guardado / Fernando Moreno.

MY SPACE
Digital Print on Vinyl
Txema Novelo © 2001 - 2005

"VII International Call for Young Artists" Luis Adelantado Gallery, Spain
Galería Luis Adelantado, C / Bonaire, 6 46003 Valencia, Spain
July 27th to September 5th, 2005

Artists: Ángel Núñez / Iván Aránega / Abdul Vas / Aggtelek / Máximo Gonzáles / Matthias Goppel / Angel Pastor / Nuno Nunes-Ferreira / Nicolás Fussler / Linarejos Moreno / Gorka Mohammed / Aitor Lajarín / Saúl Gómez / Antonio Ortega / Grupopang / Consol Rodríguez / Patricia de Sousa / Sonia Navarro / Virginia Frieyro / Txema Novelo / Paula & Gabriela / Humberto Duque / Rubén Guerrero / Juan Francisco Casas / Aaron Lloyd / Valero Rioja / Oswaldo Ruiz / Nacho Alegre / Jordi Ribes / Hisae Ikenaga.

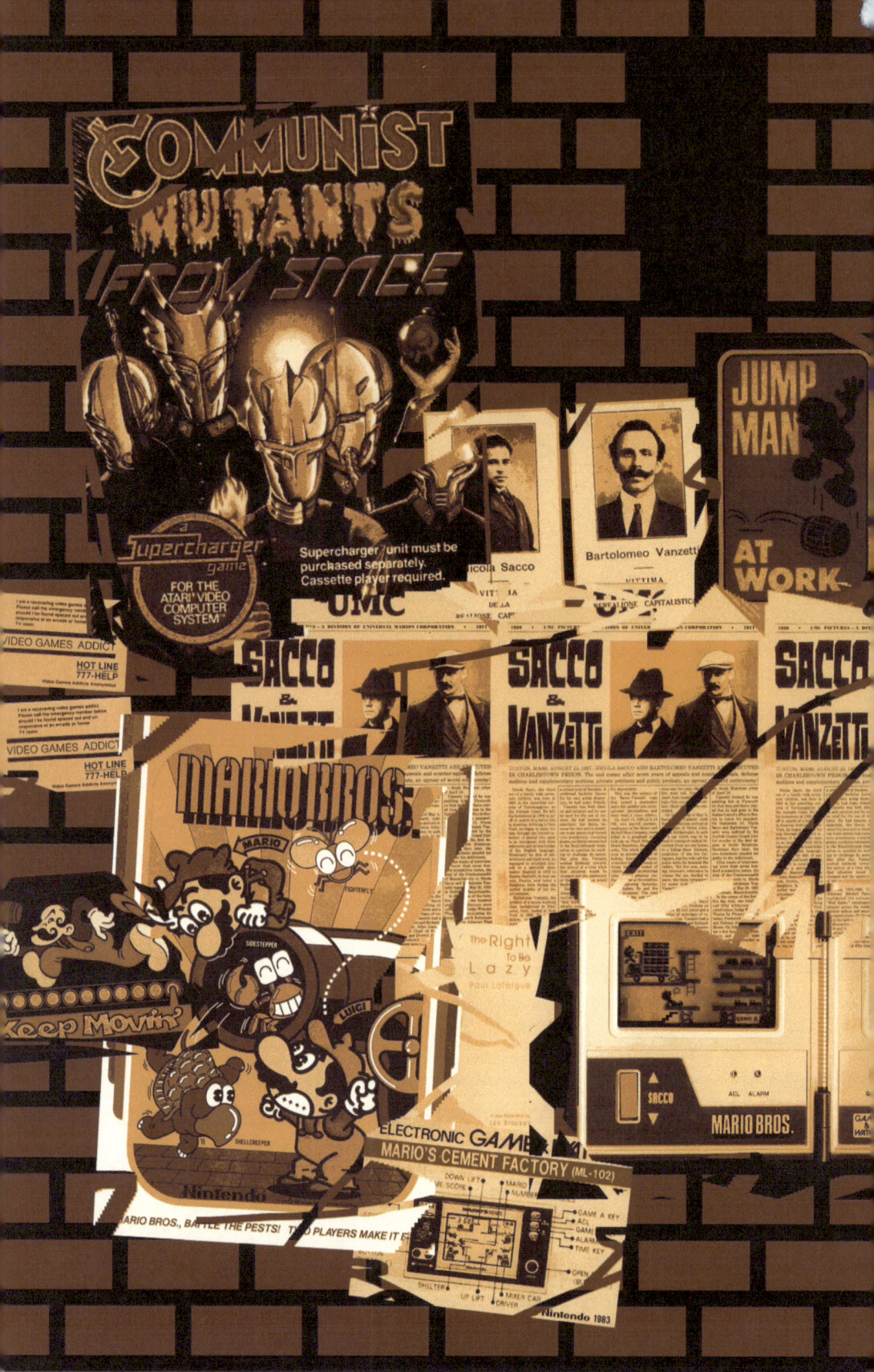

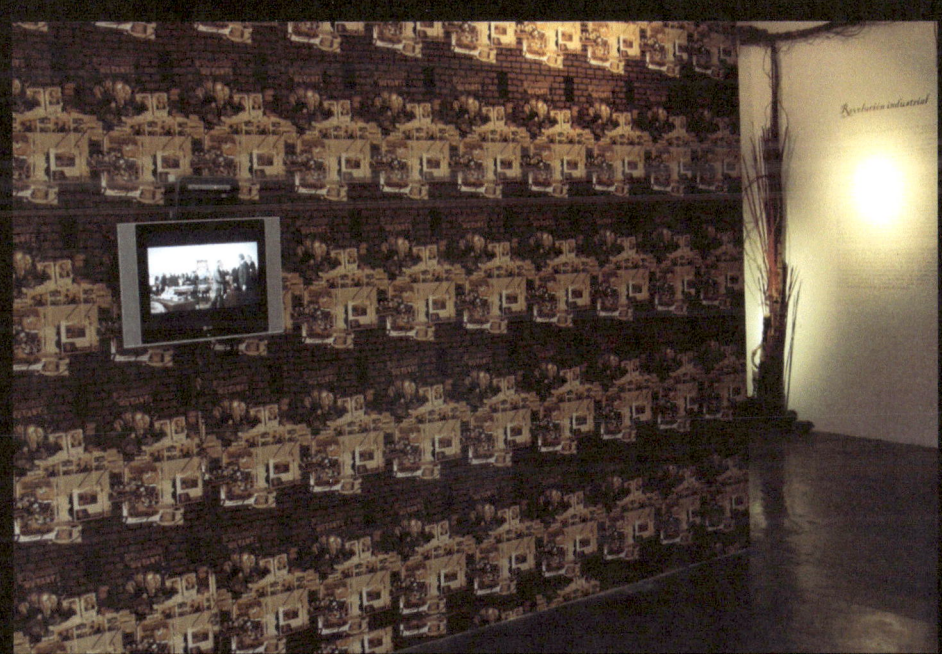

PLAYING FOR MONEY / WORKING FOR FREE
16mm Short Film + Color Print Poster + Documentation
Txema Novelo © 2006 - 2007

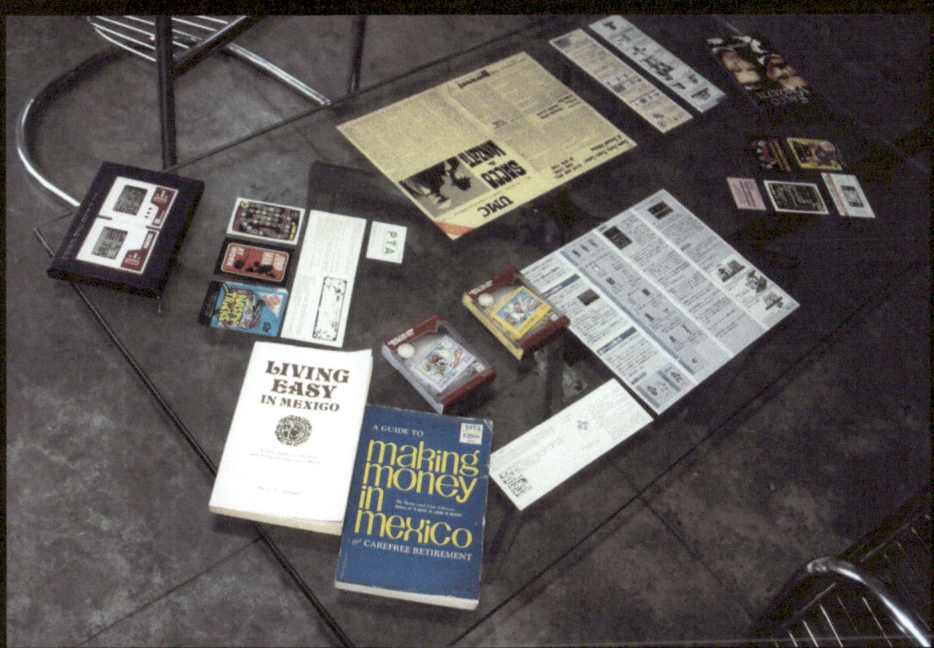

INDUSTRIAL REVOLUTION
Muca Roma
Tonala 51, esq. Colima, Colonia Roma, Mexico City
February 7th to May 4th, 2008

Artists: Milena Bonilla / David Castro / Emilio Espinosa / Javier Gutiérrez / Txema Novelo / Ana Roldan / Omar Rosales.

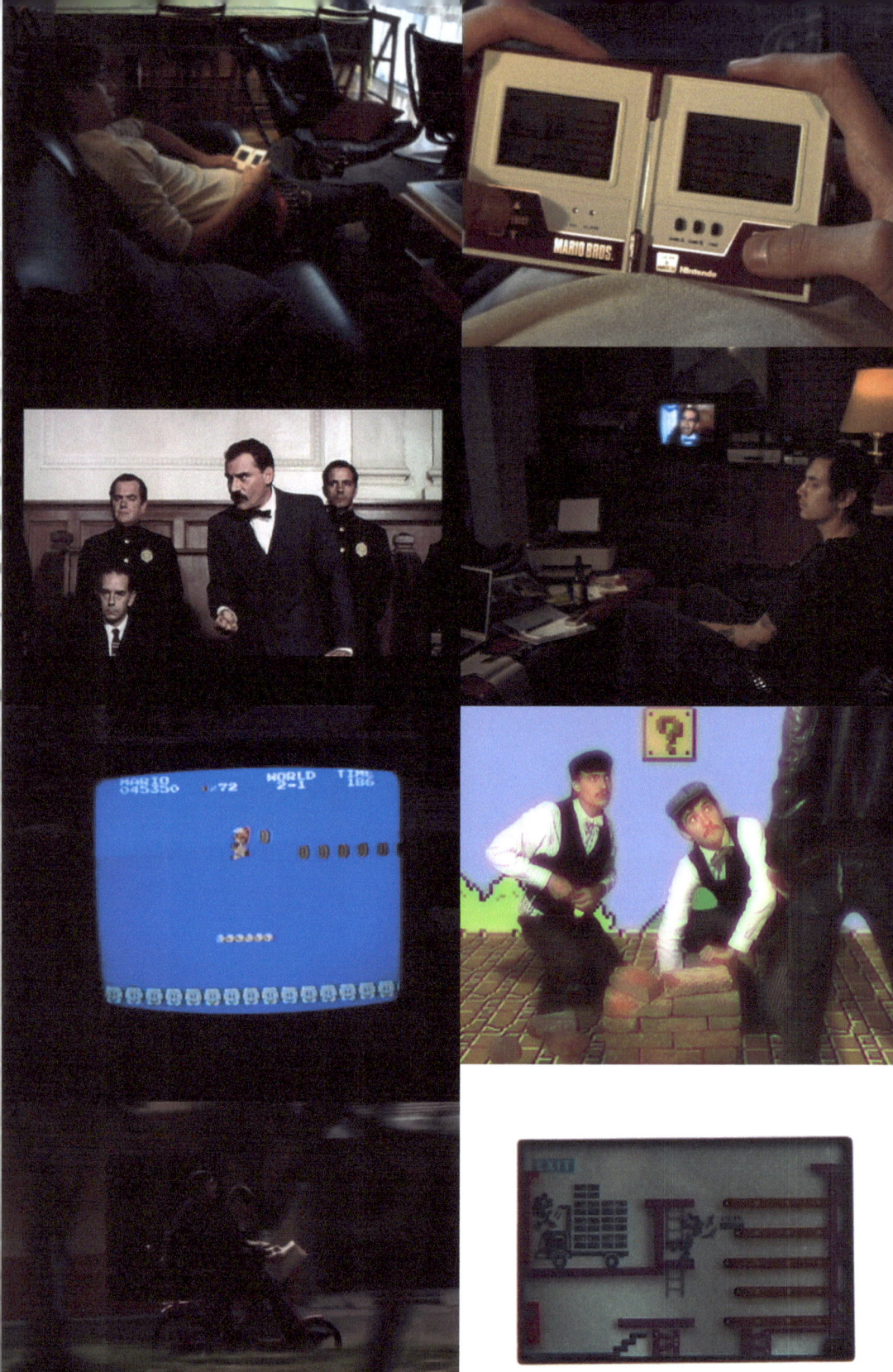

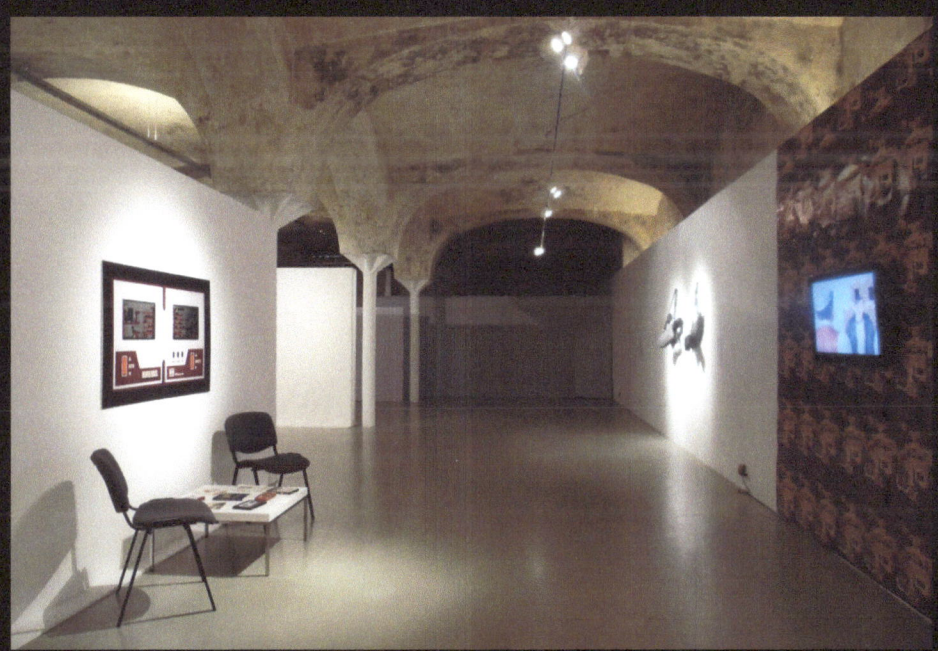

PLAYING FOR MONEY / WORKING FOR FREE
16mm Short Film + Color Print Poster + Documentation
Txema Novelo © 2006 - 2007

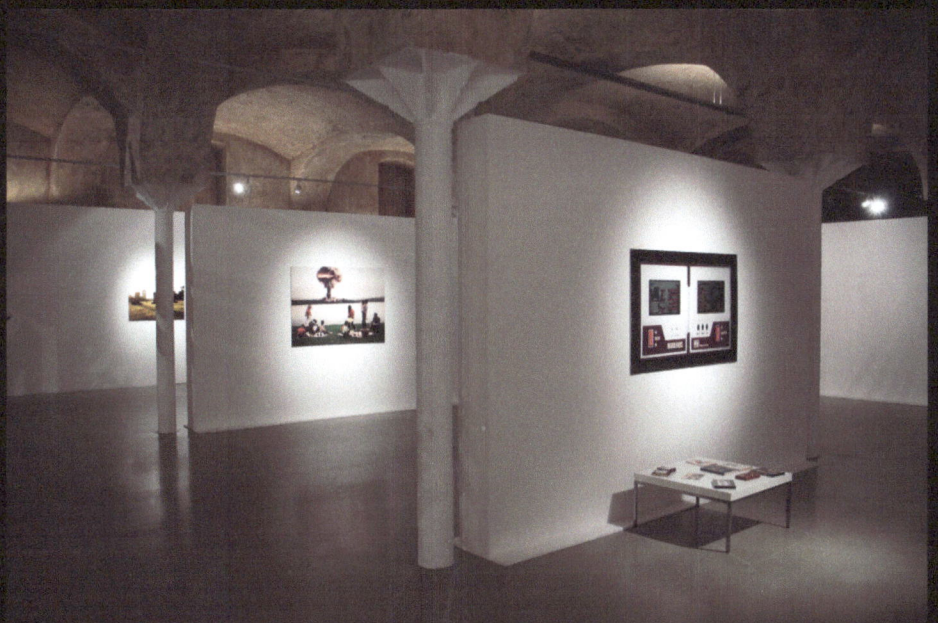

Crossing Boundaries
Mexican Art in the Second Moscow Biennial of Young Art
Contemporary Art Center Winzavod, Moscow, Russia
July 2nd to the 22nd, 2010

Artists: Artemio / Mely Barragán / Daniela Edburg / Cynthia Gutiérrez / Ximena Labra
Txema Novelo / Jaime Ruiz Otis / Daniel Ruanova / Joaquín Segura / Antonio Vega Macotela.

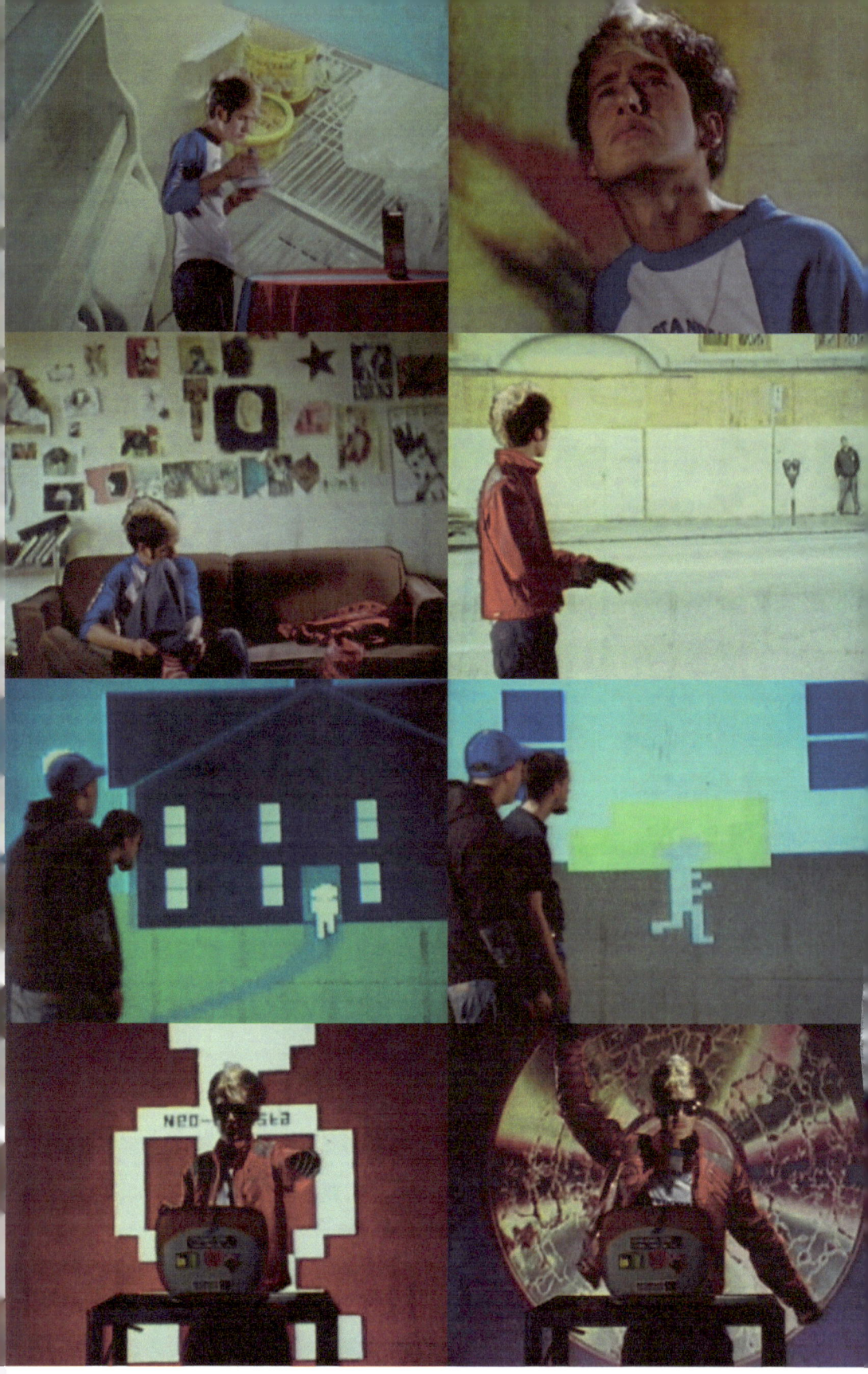

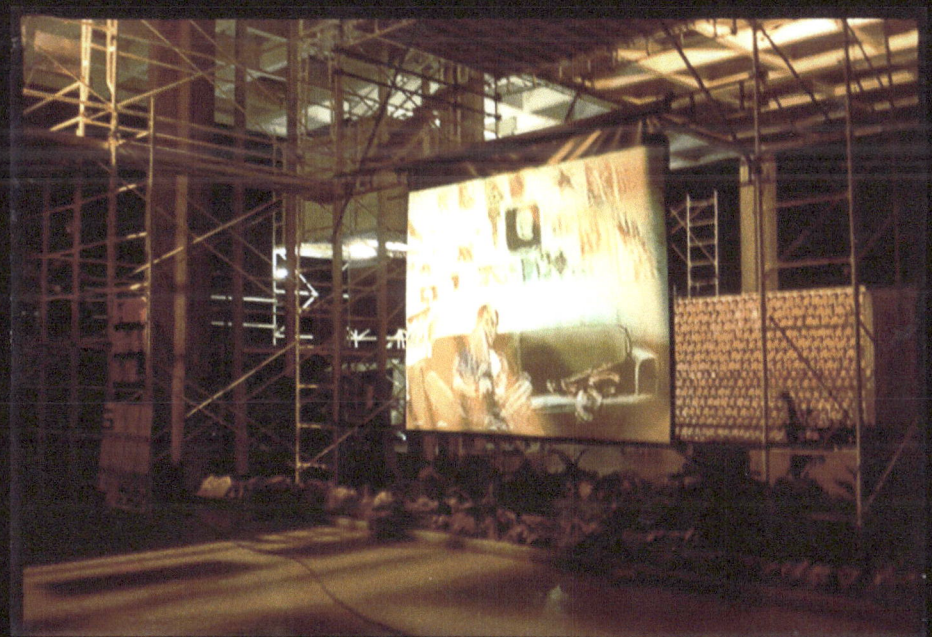

BEAT BINARIO
16mm Short Film
Txema Novelo © 2002

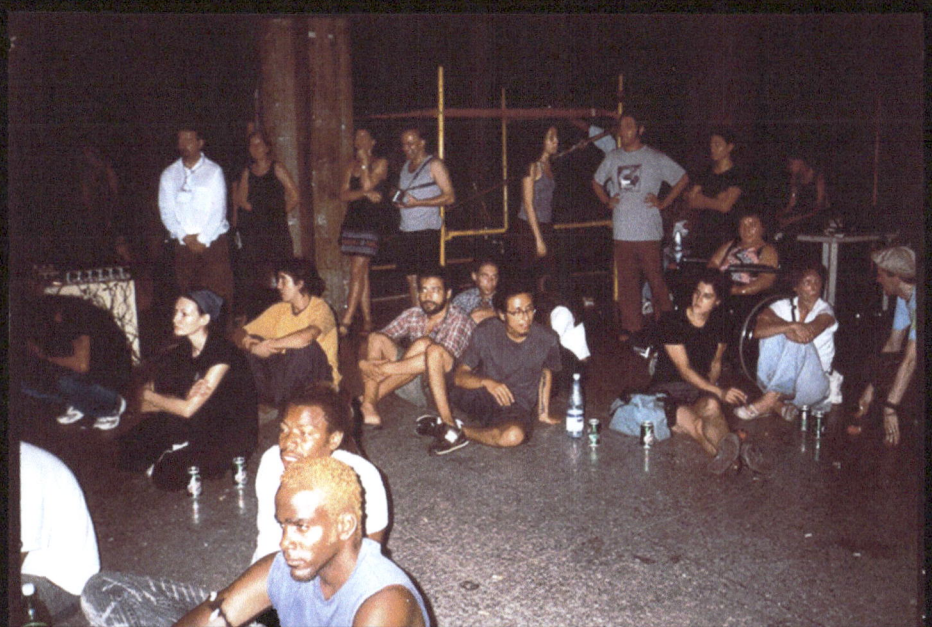

Instant Coffee at the 8th Havana Biennial
Pabellon Cuba, Calle 23 E/N y M. Vedado. Plaza de la Revolucion, Havana, Cuba
November 1st to December 15th, 2003

Artists: Meesoo Lee / Scott Russell / Galia Eibenschutz / Txema Novelo / Pedro "Zulu" Gonzales
Lisa Kannako / Miguel Calderon / Jinhan Ko / Tony Romero + Shayne Ehman / Jon Sasaki
Paige Stain / Jordan Sonenberg / Laura Cowell / Chris Mills / Greg Hefford.

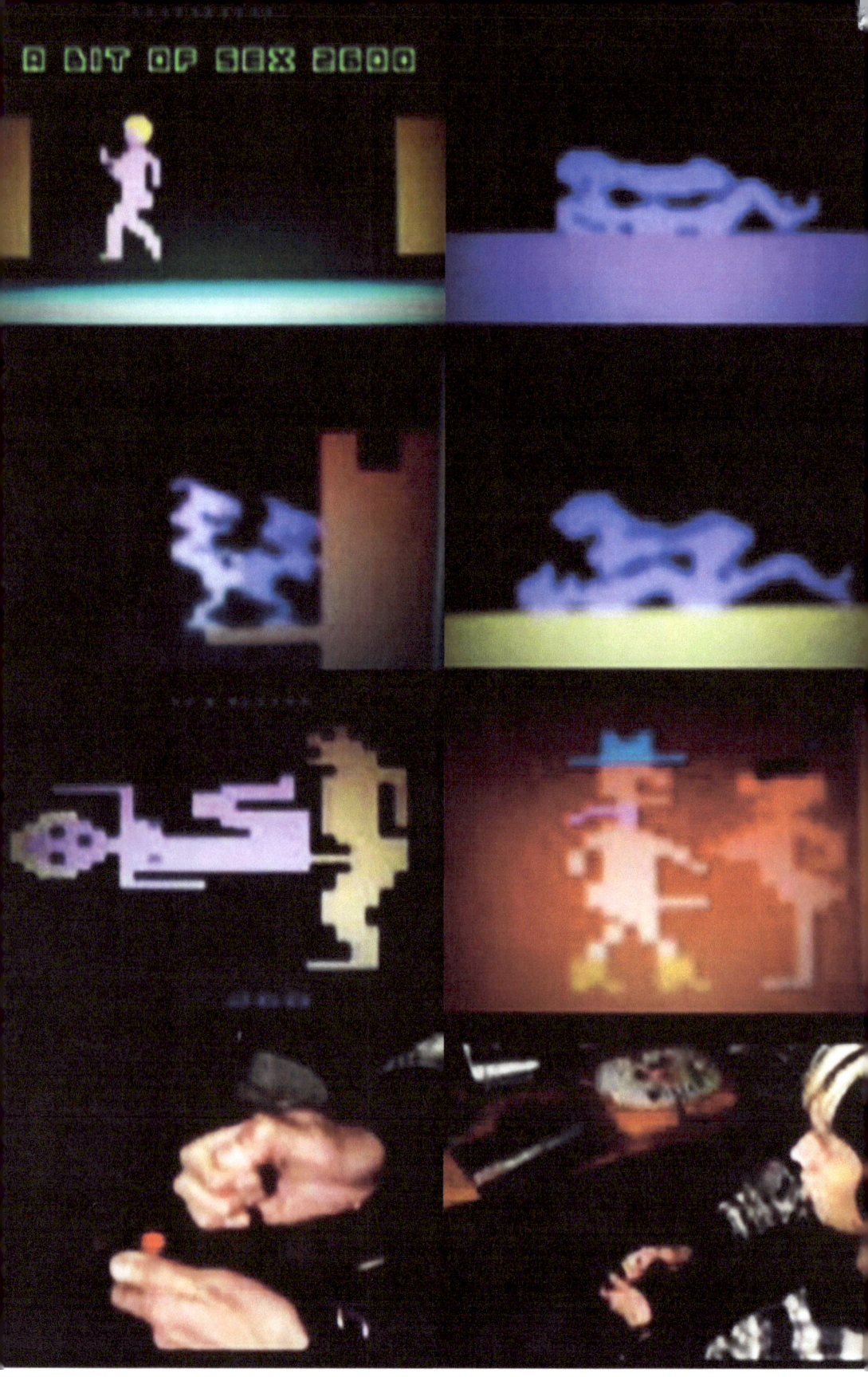

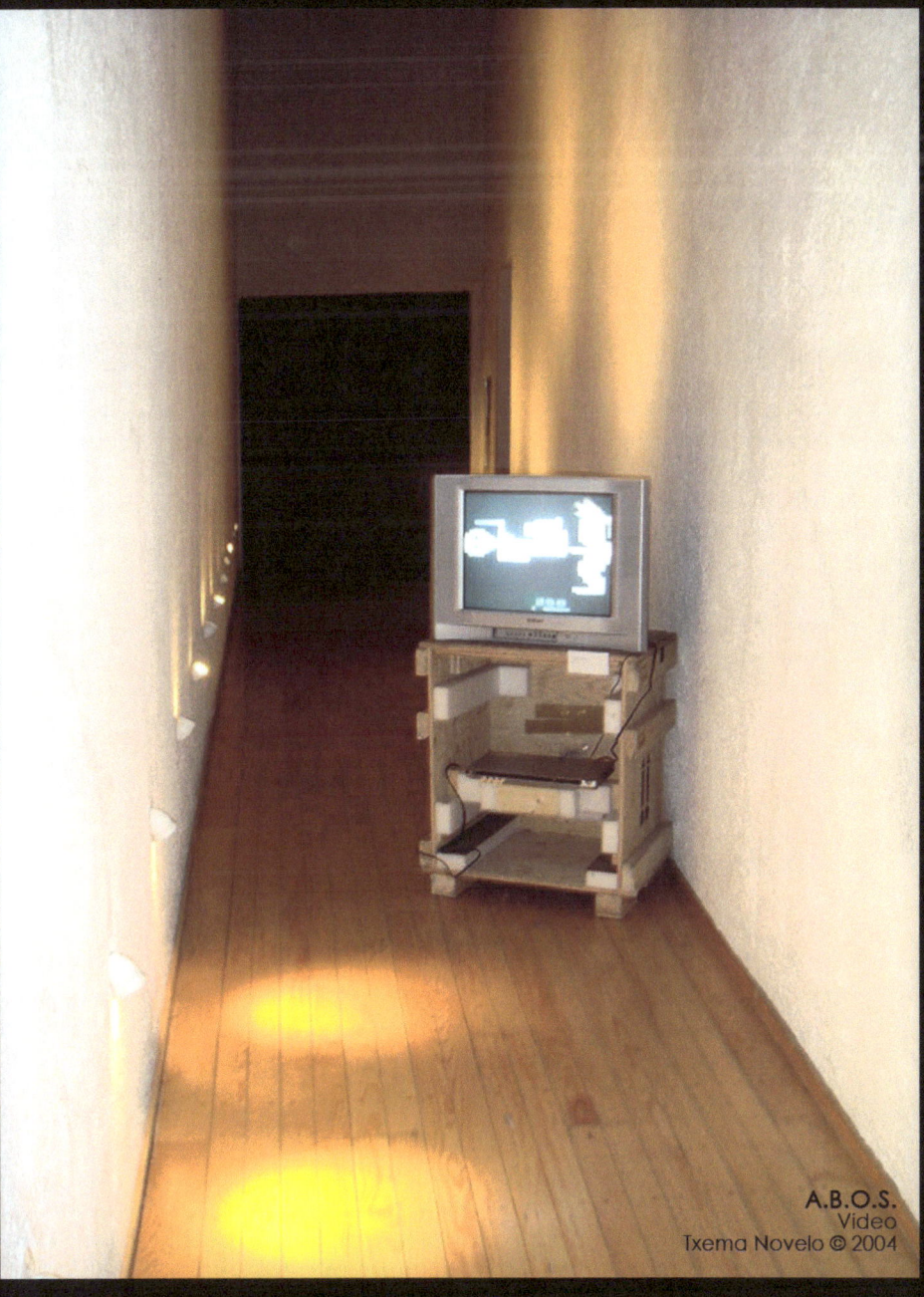

A.B.O.S.
Video
Txema Novelo © 2004

"Arcadia" Video Program
Experimental Museum "El Eco"
Sullivan #43, Col. San Rafael, Mexico City.
November 14th, 2006

Artists: Antoine Catala / Rodolfo Díaz Cervantes / Paulina Lasa / Txema Novelo.

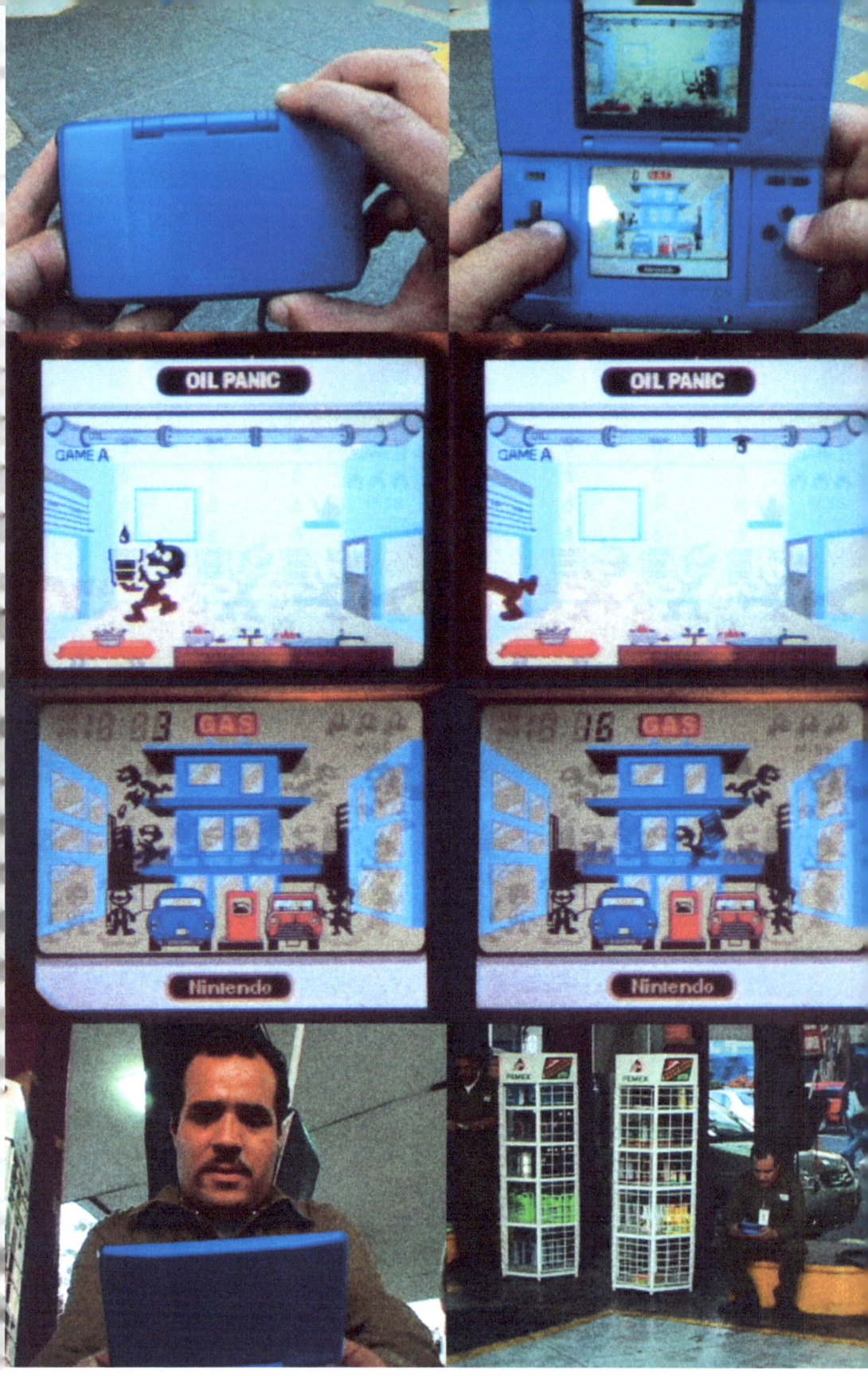

OIL PANIC (From the Film Series MINIMUM WAGE / MAXIMUM SCORE)
Super 8mm Color Reversible Film inside of a Fisher Price Movie Viewer Cartridge
Txema Novelo © 2008

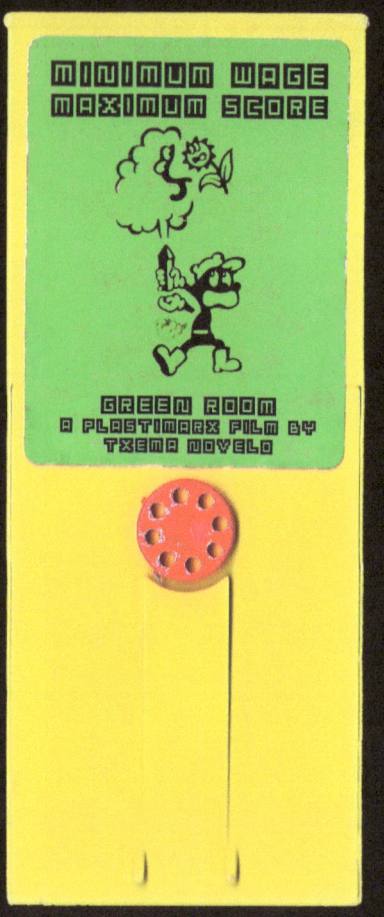

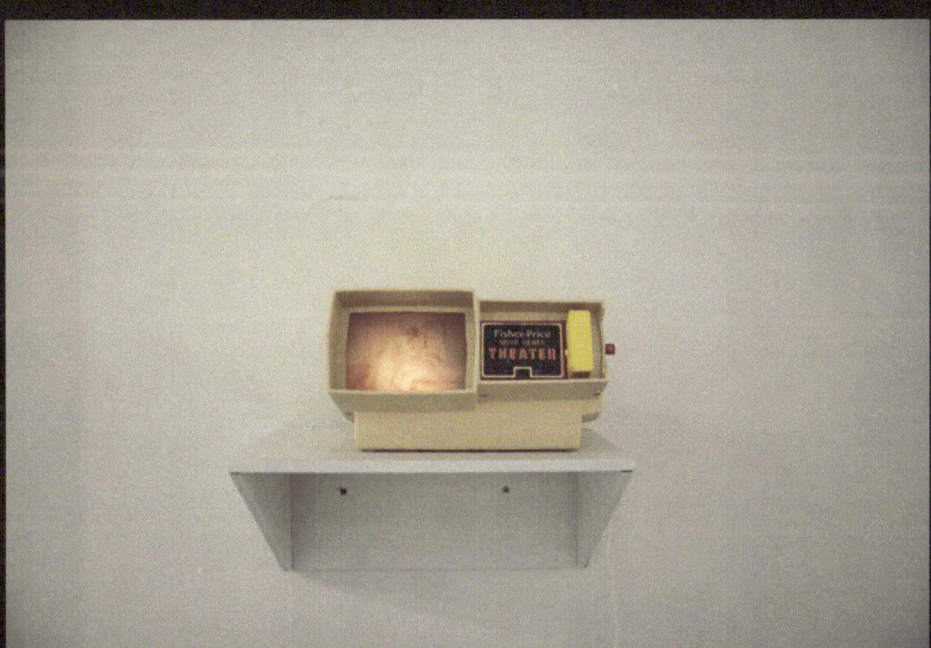

GREEN HOUSE
Super 8mm Color Reversible Film inside of a Fisher Price Movie Viewer Cartridge
Txema Novelo © 2008

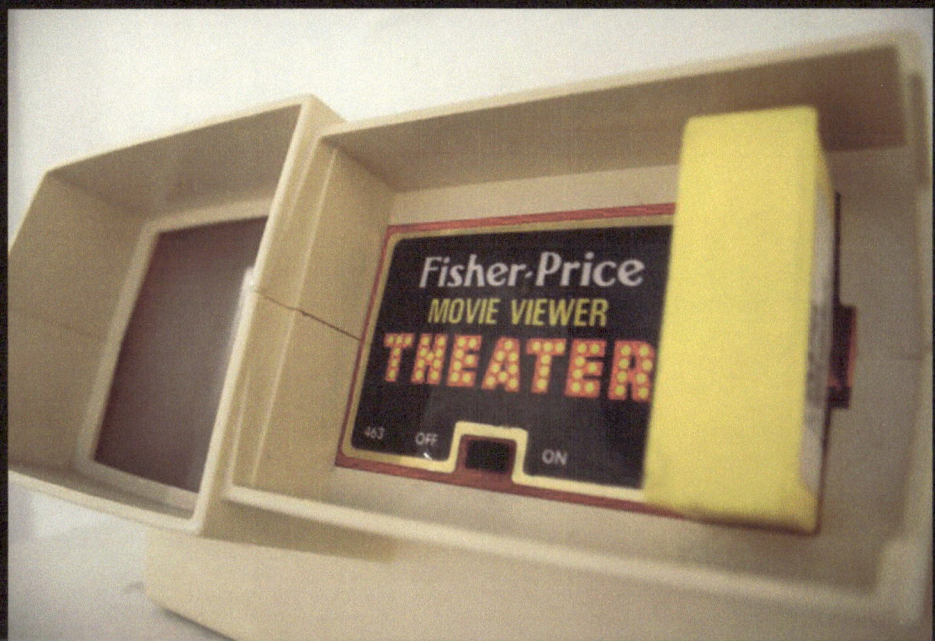

FANTASTIC FOUR
Galería La Refaccionaria
Bucareli 128 int. E40, Colonia Juárez, Edificio Vizcaya, Mexico City
October 24th, 2009

Artists: Alejandro García / Carolina Esparragoza / Fabián Ugalde / Iván Trueta / Lorenzo Ventura / Mariana Magdaleno / Rafael Capilla / Ricardo Atl / Rodrigo Sastre / Tania Candiani / Txema Novelo.

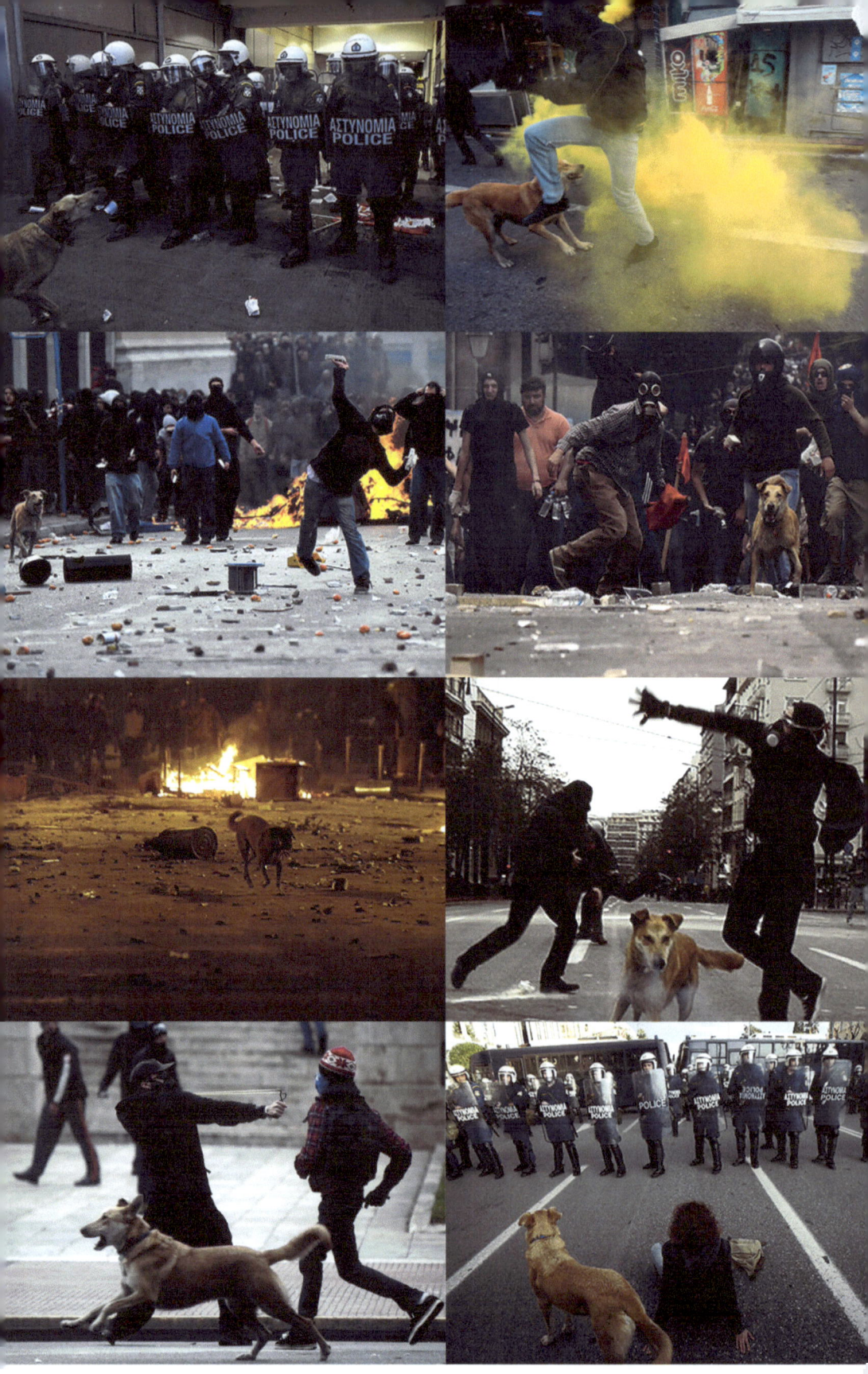

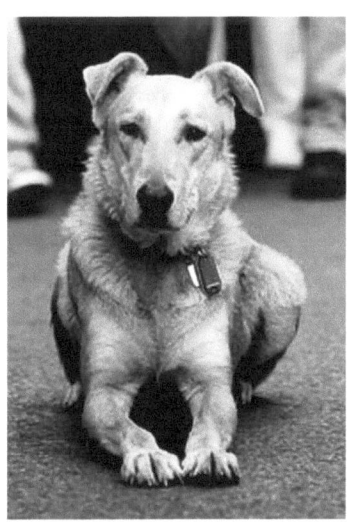

KANELLOS MY LOST DOG
Poster
Txema Novelo © 2010

Guitar Army

John Sinclair

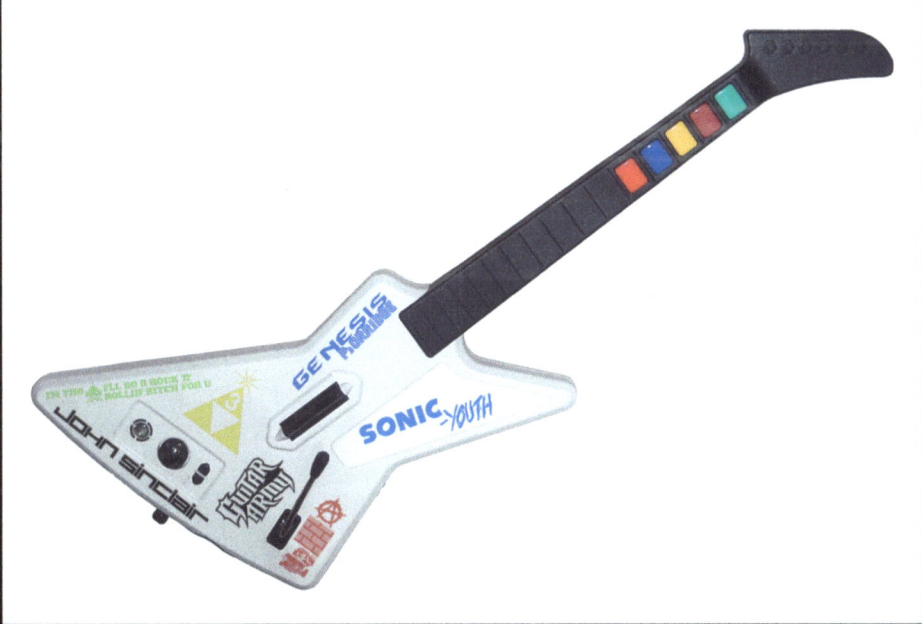

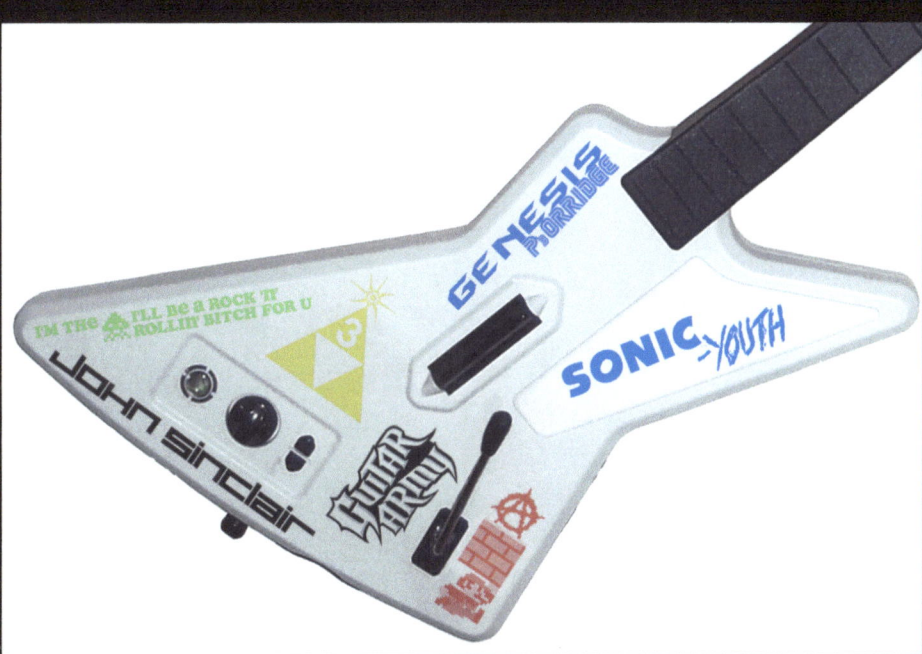

GUITAR ARMY (Inspired from John Sinclair's White Panther Party Book)
Stickers for Guitar Hero Guitars.
Txema Novelo © 2010

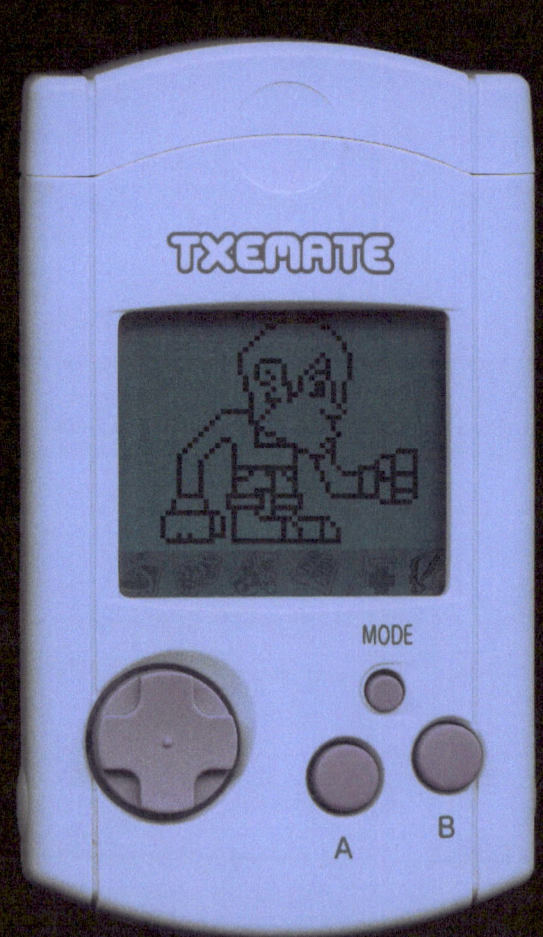

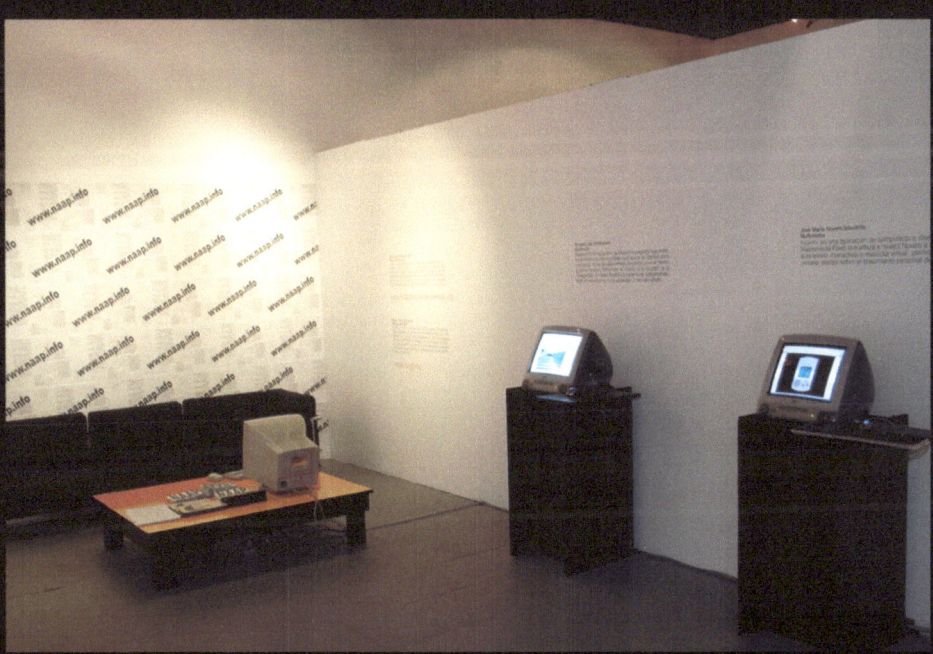

TXEMATE
Computer Application
Txema Novelo © 2004 / 2005

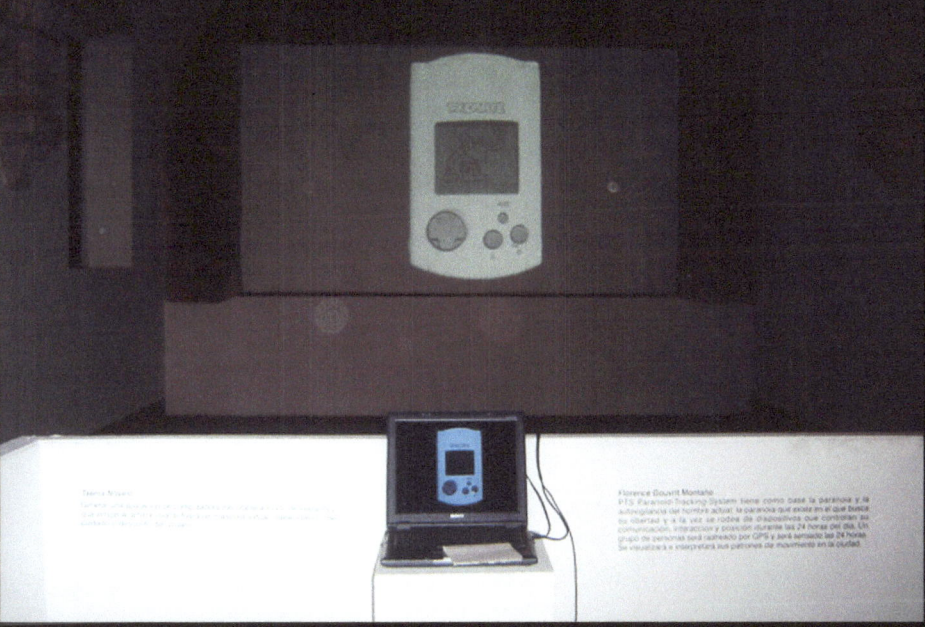

"Creation in Movement" National Grant for Young Artists FONCA
Central Gallery of the National Center for the Arts, **CENART**
Río Churubusco and Calzada de Tlalpan, Col. Country Club, Mexico City
July 20th, 2006

Artists: 5 Multimedia Grant Holders of the National Young Artist Grant FONCA, 2004 / 2005 Class.

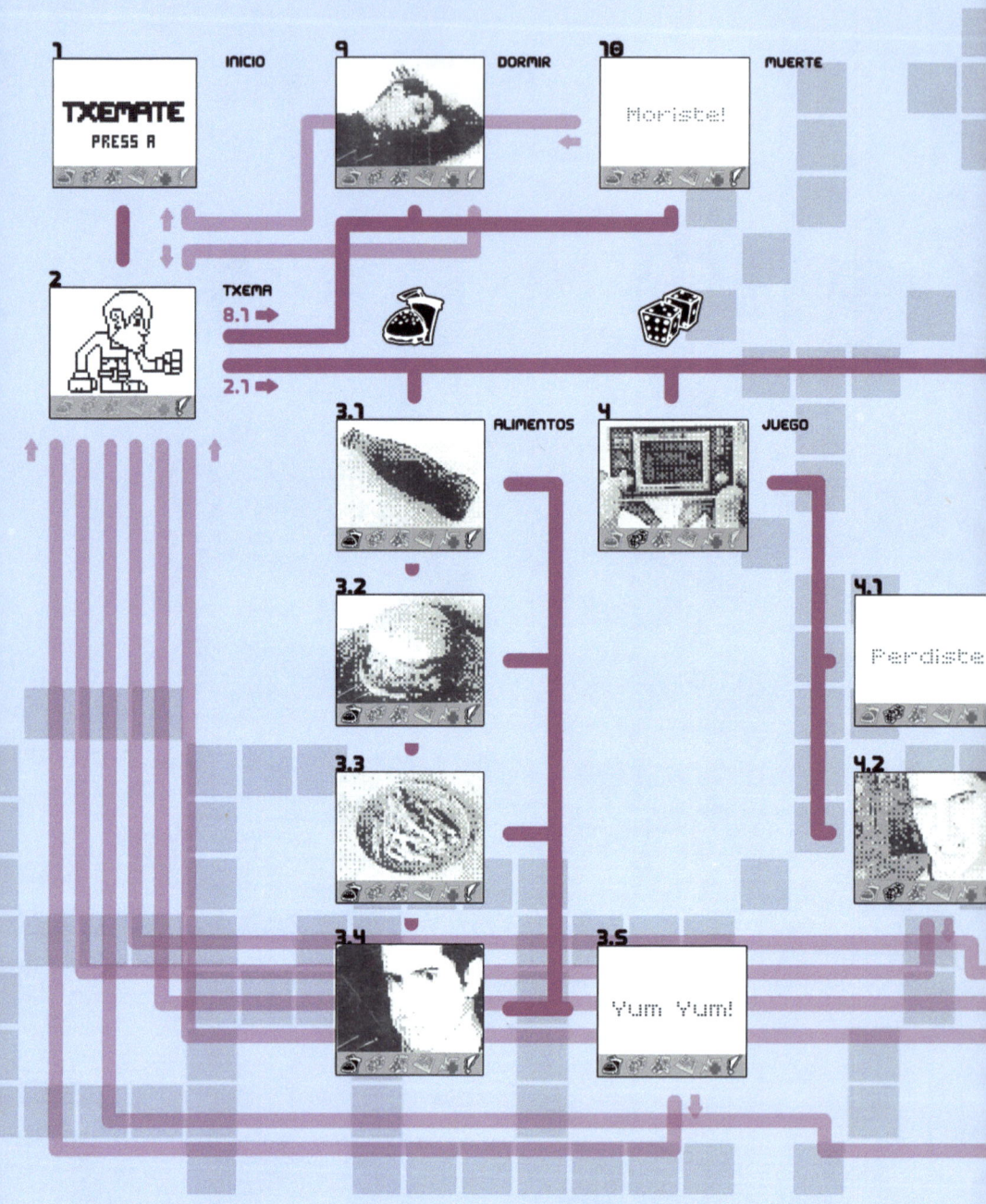

PROYECTO MULTIMEDIA DE TXEMA NOVELO PARA EL PROGRAMA JOVENES CREADORES 2004-2005.

TechCrunch

Forum About Contact Company Index Advertise Archives Toolbar Cool Jobs TC40

« Previous post Next post »

July 14 2007

Will The Last Corporation Leaving Second Life Please Turn Off The Light

Duncan Riley 73 comments »

The LA Times **has an interesting** article up on the failure of real life businesses in Second Life.

The crux of the piece is that despite the hype, real life businesses are closing down their Second Life outposts due to little to no interest in them.

The reasons for the failures are open to debate; from firms not engaging Second Life citizens, through to simply a lack of actual people using Second Life (the LA Times says it peaks at 40,000 users at any one given time).

Wagner James Au at GigaOm has a **set of figures** worth looking at. In defending Second Life, Au notes that the visitor rate to corporate installations on Second Life is 0.8-2% vs a CTR rate on standard web advertisements on 0.5-1%. Great, but does a higher CTR really matter? The 5 most popular corporate destinations on Second Life have between 1200 to 10,000 visitors per week. An island on Second Life (a popular choice for corporations) costs $1,675 upfront then $295/ month, and that doesn't include the cost to actually create structures on the island from one of the various Second Life design firms (cost: approx $5-10,000). So lets do the figures: the most popular corporate destination has 10,000 visitors per week; at $295/ mth in maintenance fees that's a CPM rate of approx $7.40. The bottom destination of the top 5 has a CPM rate of approx $61. If we apportion the upfront costs of design (say $5,000 although it's probably higher) and setup ($1675) over 12 months the CPM rates become $21.20 (top) and approx $180 (bottom of the top 5). The CTR rate is irrelevant: the CPM cost for businesses on Second Life is insane: simply even for the very best, the figures don't add up.

Au's later notes **in the same post** that Second Life doesn't rely on corporations for revenue and the decline of corporations on Second Life doesn't really matter all that much to Linden Lab. Once the last corporation leaves Second Life, the user-generated metaverse will continue, and in some ways may even end up being better off.

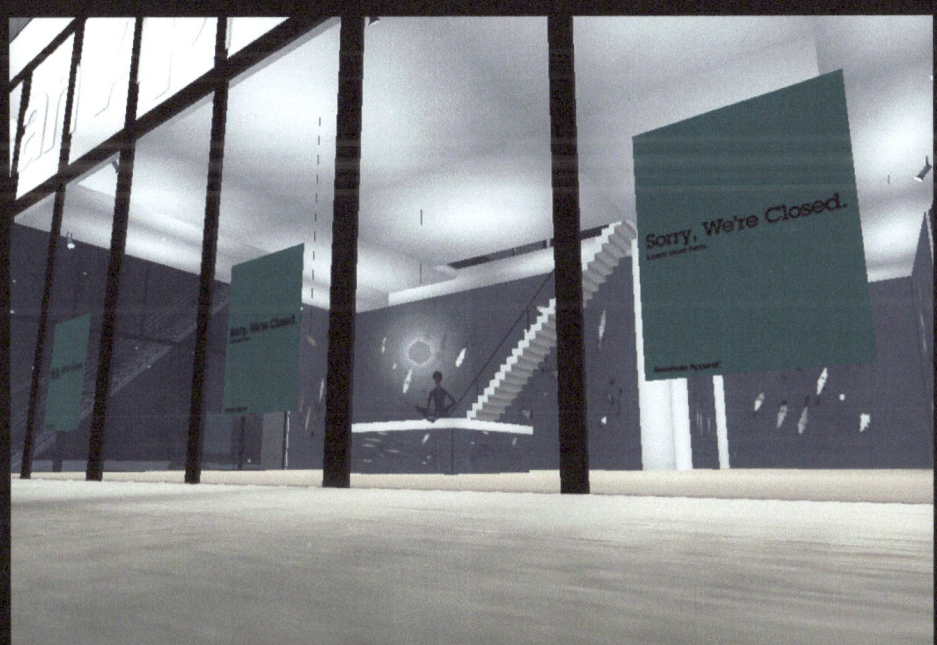
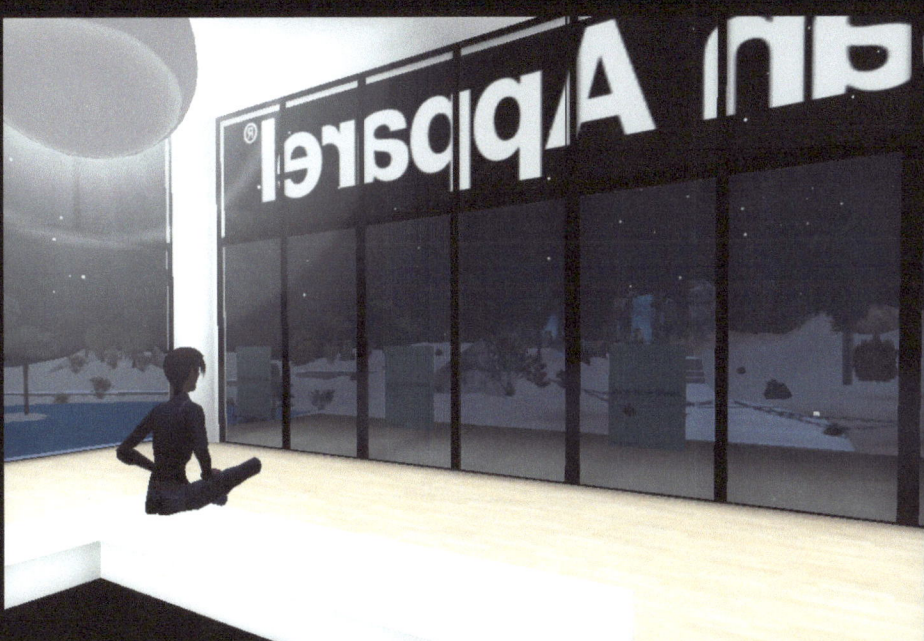

CORPORATION SQUATTER "AMERICAN APPAREL"
Digital Prints from "In World" Second Life App
Txema Novelo © 2008

Brands fade out in Second Life

Mark Ritson
September 6, 2007

FOR the past 18 months there has been a growing buzz about the amazing virtual world of Second Life. The site offers the chance to create an alternative identity (known as an avatar), and hang out in a virtual world on the internet with other global citizens and interact in a variety of ways.

With Second Life claiming that more than 8 million people have spent time on the site, it was inevitable it would become more commercial. A host of big-name international brands have now set up a presence on Second Life.

The first was US retailer American Apparel. The store sold virtual clothing designed to be worn by the avatars that populate Second Life. Other brands soon followed. In October, Starwood, owner of hotel brands such as Westin and Sheraton, premiered its Aloft hotel brand on Second Life. Starwood saw its virtual hotel as a way of generating customer insights about its venture long before any of the hotels opened.

A month later, US car maker Pontiac launched Motorati Island. According to Pontiac marketing director Mark-Hans Richer, it was designed to "empower the car community in Second Life and develop with them in a unique and meaningful manner".

From April, Second Life boasted the ultimate marketing patronage when Coke launched a "virtual thirst pavilion", where visitors could compete to create a virtual vending machine selling not Coke, but, according to the company's website, "the essence of Coca-Cola: refreshment, joy, unity, experience".

By the middle of this year, some of the most recognised brands in Australia had moved into Second Life — Intel, adidas, Dell and Toyota. From media coverage it seemed as if Second Life was the next marketing frontier, an incredible place where brands could be built virtually to a global population.

It all sounds amazing, until you visit Second Life. Walking (or flying) around this virtual universe is a disappointing experience. The strange, dislocated setting and only the occasional presence of anyone are disconcerting. The virtual branded locations that sounded so impressive in the pages of *BusinessWeek* are basic and devoid of visitors. Despite Second Life's bold claims of millions of residents, the limited server space means locations can handle only 70 avatars at a time. But once you leave the congested entry portal, this is hardly a problem as most of the site is eerily quiet and deserted.

In the past month, several of the big brands that trumpeted their arrival on the site are quietly backing away. The lack of visitors or any sound strategic rationale for being there have begun to affect many of them. American Apparel has all but given up on its virtual store, citing the criticism it has received and "insignificant" sales. Starwood is also set to leave the site. Only Coca-Cola is bullish about Second Life. Michael Donnelly, the company's head of interactive marketing, accepts that much of Second Life is empty, but says: "My job is to invest in things that have never been done before."

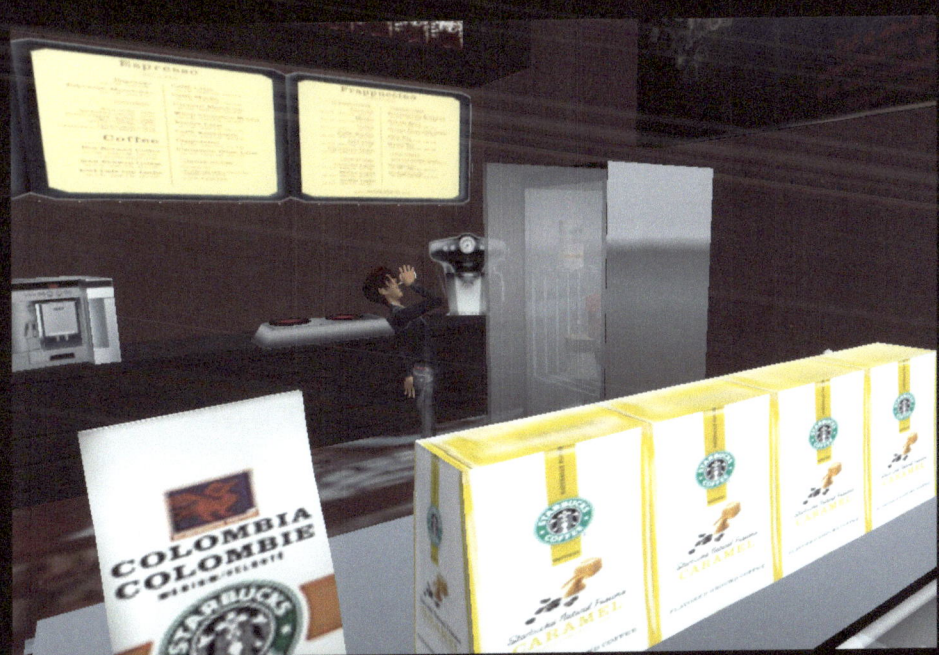
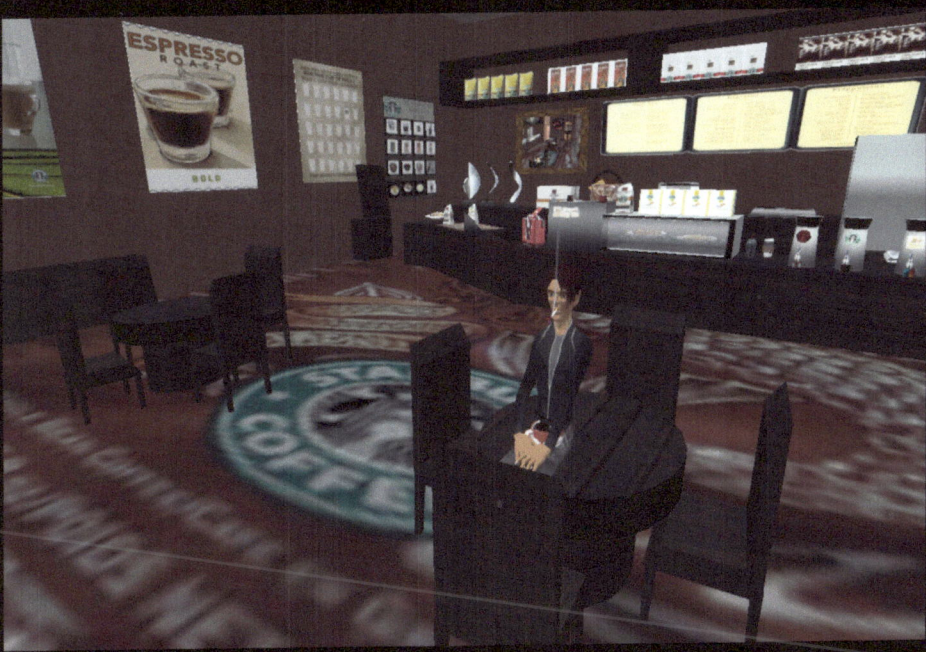

CORPORATION SQUATTER "STARBUCKS COFFEE"
Digital Prints from "In World" Second Life App
Txema Novelo © 2008

Second Life's Real-World Problems

By KRISTINA DELL

Thursday, Aug. 09, 2007

ENLARGE PHOTO

ILLUSTRATION BY FRANCISCO CACERES FOR TIME

Reality is catching up with Second Life, the much hyped 3-D website that lets users create alter egos called avatars who can walk, chat, fly, have sex and buy and sell virtual stuff for real money. The ballyhoo surrounding this online community has led multinational brands from Reebok to Toyota to establish beachheads on Second Life to interact with consumers and be a part of the next wave in social networking. In April market-research firm Gartner predicted that by the end of 2011, 80% of active Internet users will have some sort of presence in a virtual world, with Second Life currently one of the most populous. Business Week last fall put on the cover a real estate agent whose virtual land deals made her the first person to earn $1 million through the site, and TIME included Second Life creator Philip Rosedale in this year's list of the world's 100 most influential people. Even NBA commissioner David Stern now has a Second Life avatar, although he told TIME, "I don't think it captures the essence of my personality or good looks." He was kidding, but the site's failure to live up to expectations is serious business.

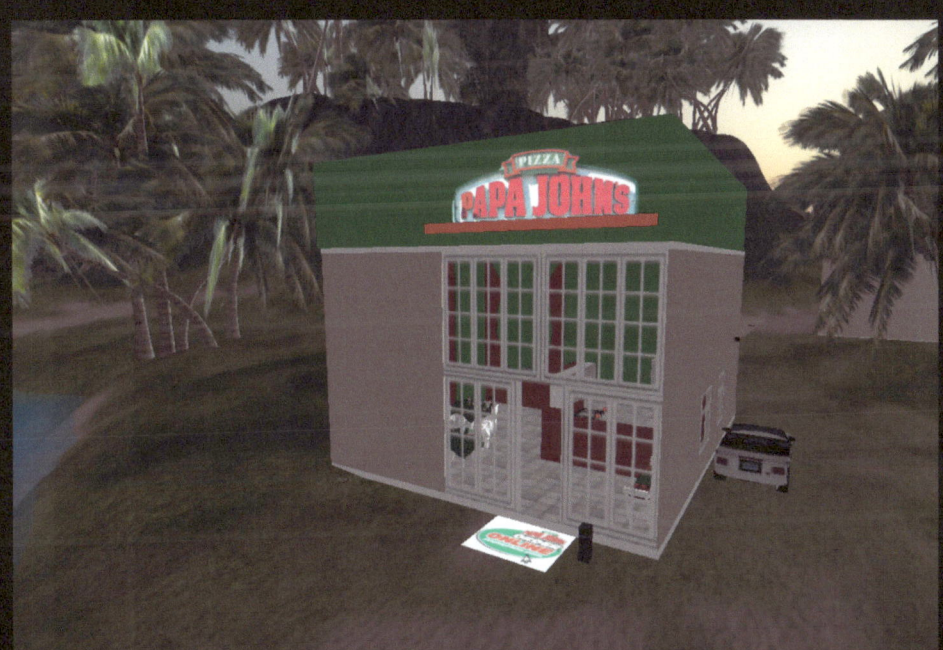
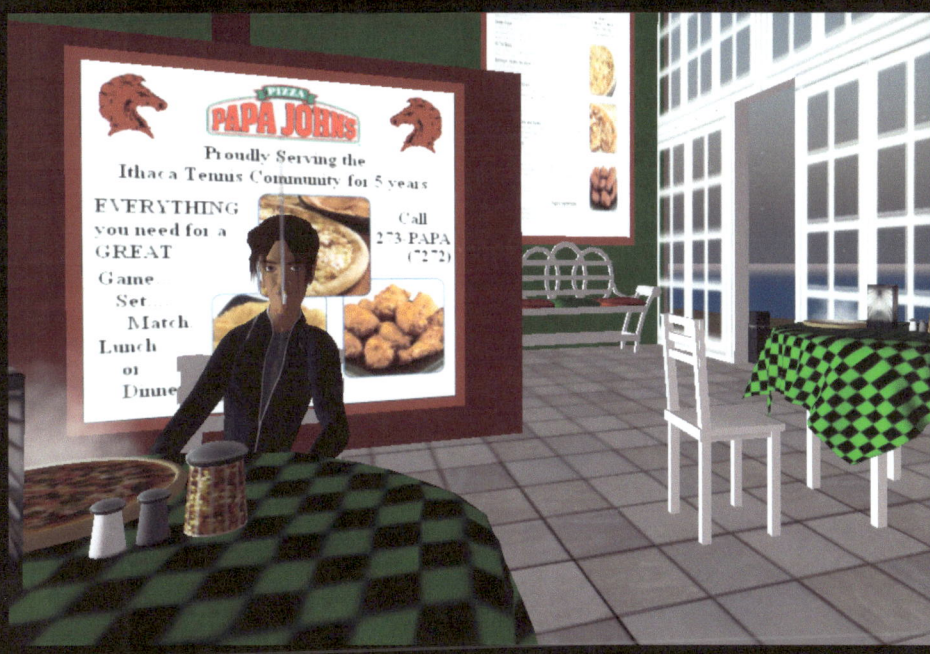

CORPORATION SQUATTER "PAPA JOHNS"
Digital Prints from "In World" Second Life App
Txema Novelo © 2008

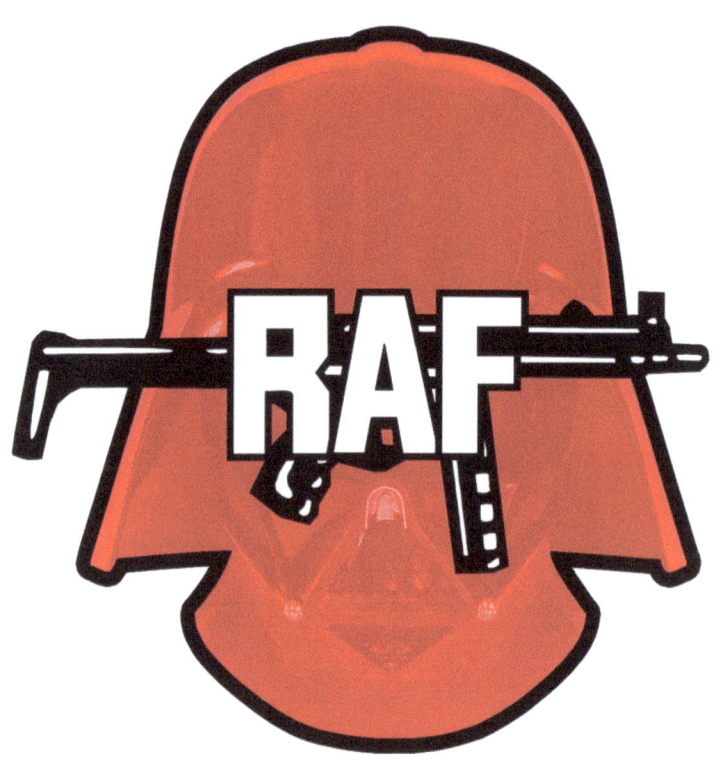

Die Darth Baader / Meinhof Bande

REVOLUTION AND FUN (RAF)
Poster
Txema Novelo © 2010

(READY) MEDIA: HACIA UNA ARQUEOLOGÍA
DE LOS MEDIOS Y LA INVENCIÓN EN MÉXICO

(READY) MEDIA: HACIA UNA ARQUEOLOGÍA DE LOS MEDIOS Y LA INVENCIÓN EN MÉXICO

DVD 5
AUDIOVISUAL EXPERIMENTAL CONTEMPORÁNEO
por David Wood

PROGRAMA
1. ORÍGENES | TECNOLOGÍA
Los rollos perdidos de Pancho Villa, 8'54" (dos fragmentos), Gregorio Rocha, Video DV, 2003
Muybridge cuántico, 0'37", Juan Carlos de la Parra, Mini DV, 2008
Lula (De la serie Lost Portraits), 0'37", Ricardo Nicolayevsky, Super-8, 1982-1985
El pintor loco, 8'11" (fragmento), Jorge Izquierdo, Javier Sánchez y Daniel Quiróz, Video DV, 2008
Noelia, la otredad, 3'21", Enrique Favela, Filme estenopéico, 2008
Stereovisión, 7'25" Fernando Llanos, Mini DV/Video celular, 2008

2. VOCES
Voces de la Guerrero, 10'52" (fragmento), Adrián Arce, Diego Rivera y Antonio Zirión, Mini DV, 2004
Xanini-mazorcas, 7'59", Dante Cerano, Mini DV, 2004
The American Egypt, 11'34" (fragmento), Jesse Lerner, 16mm, 2001
Exotic Nippon, 2'06", Bruno Varela, Super-8, 2008

3. FRONTERA
A Visible Border, 2'41", Alex Rivera, DV, 2003
Fronterilandia, 9'19" (fragmento), Jesse Lerner y Rubén Ortiz, 16 mm, 1995 (incluye versión con comentarios de los realizadores)
Transmigraciones, 7'08", Juan Carlos de la Parra, DV, 2004
Tracking Memory-Scarlet, 5'45", Amanda Gutiérrez, DV, 2008

4. CUERPO
Tensa calma, 8'31", Alfredo Salomón, HD, 2008
Muxes, Auténticas intrépidas buscadoras del peligro, 5'27" (fragmento), Alejandra Islas, Mini DV, 2005
Spanking the Jello, 4'27", Claudia Prado, Mini DV, 2002
Cama, 1'59", Ximena Cuevas, DV, 1998
Nací mujer, Whatever that Means, 4'24", Grace Quintanilla, Mini DV, 2003
Mientras dormías, 10'36" (documentación de performance), Lorena Wolffer, Mini DV, 2002
Mujer Rota, 4'30", Jessica Cruz, DV, 2003

5. MOVIMIENTO | PERCEPCIÓN
Correr entre bejucos, 0'58", Bruno Varela, Super-8 y DV, 2006
Paisaje después de la niebla, 4'20", Sarah Minter, Mini DV, 2008
[N], 3'33", Francisco Westendarp y Ana Méndez, 16mm B/N, 2008
Paseo catódico, 6'52", Manolo Arriola, Mini DV, 1999
Feliz cumpleaños, 5'07", Luis Emilio Valdés, DV, 2006
Poetry in Motion, 11'09" Maria José Alós y Artemio Narro, Mini DV, 2004

6. MEDIACIÓN | CONSUMO
...De negocios y placer, 1'37", Iván Edeza, Mini DV, 2000
Lesson 12, 3'26", Bruno Varela, DV, 2007
Invasión doméstica, 3'16", Paulina del Paso, DV, 2002
Hubris 1.0, 11'40", Eduardo Thomas, DV, 2009
Phonesex, 0'56", Domenico Capello, Mini DV, 2001
The Big Whack, 2'28", Ricardo Nicolayevsky, 16mm, 2002
Playing for Money, 12'15", Txema Novelo, 16mm/DV, 2007
No D.R., 0'57", Alfredo Salomón, Mini DV, 2002

DVD 6
VOICE OVER I
por Tania Aedo y Karla Jasso

Ariel Guzik, 13'26", realización: Camper Media, HD, 2010	
Ximena Cuevas, 19'26", realización: Camper Media, HD, 2009	
Sarah Minter, 9'56", realización: Camper Media, HD, 2009	
Arthur-Henry Fork, 7'46", realización: Camper Media, HD, 2009	
Arcángel Constantini, 14'44", realización: Camper Media, HD, 2009	

(READY) MEDIA: TOWARDS AN ARCHEOLOGY OF THE MEDIA IN MEXICO
DVD Compilation Comissioned by Laboratorio de Arte Alameda Museum
"Minimum Wage / Maximum Score" as part of DVD 5, Curated by David Wood.
LAA © 2010

mART 2009/2010:
SELECTION OF EMERGING ARTISTS FOR NEW COLLECTORS

Murrieta Foundation Biennial Catalogue of Emerging Artist for New Collectors. Featuring the works of:

Omar Aguayo Meza / Ricardo Alzati / Omar Emir Barquet / Tania Candiani / Mauricio Carlos Martínez / Débora Carnevali / Gabriel Carrillo de Icaza / Anibal Catalan / Colectivo Marcelaygina / Ricardo Cuevas / Elizabeth de Jesus / Gabriel Díaz Garcilazo / María Ezcurra / Alejandro Fournier / María García-Ibañez / Rodrigo Sastre / Rosaura García / Mauro Giaconi / Alejandro Gómez Arias / Omar Góngora / Rocío Gordillo de Lira / Aldo Guerra / Mariana Gulico / Daniel Gutiérrez Toca / Karla Hernando Flores / Hisae Ikenaga / Fritzia Irizar Rojo / Mariana Magdaleno / Manuel Mathar / Samuel Meléndrez / Carlos Mier y Terán / Ernesto Morales / Amor Muñoz / Txema Novelo / Hugo Pérez Gallegos / Ivan Puig / Cecilia Ramírez / Darío Ramirez / José Rodríguez / Xavis Rolo / José Luis Rojas / Roberto Romero-Molina / Roberto Guerrero / Neli Ruzic / Alma del Carmen Sandoval / Daniel Solano / Isaac Torres / Ivan Trueta / Alfonso Zárate.

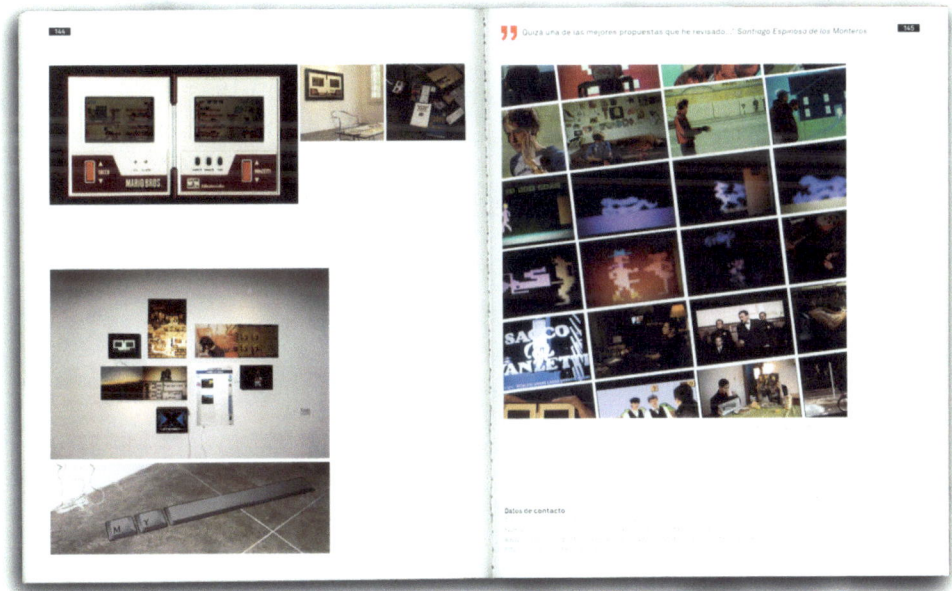

INTENTIONALITY TEXT:

I see with joy how my work gets closer everyday to Marxism (Specially the Groucho vain), The proletarian struggle of the Super Mario Bros, the legislation, protection and care of Virtual Pets, the altruist work field in favor of Thee Temple ov Psychick Youth, The Andy Warhol and Jack Smith Movies and the morals of the Left wing oriented teen show "Pete & Pete".

This fueled by the old fashion consumption of all kinds of Rock & Roll, besides the old fashion consumption of all kinds of psychoactive drugs.

**REBELLIOUSNESS:
THE RUMOR OF THE MOMENT**
Book of Contemporary Essays by Young Mexican Writers and Artists on "Disobedience" as the main Subject.

Edited by the National Autonomous University of Mexico UNAM © 2010.

El rumor del momento

prólogo → 6
colaboraciones:
Stavros Kassis
Des-velar la Rebelión → 13
Alberto Navarro
Carlos Aguirre → 16
¡Viva la digna resistencia de este pueblo libre! → 18
Alejandra Castro
Necesitamos un pueblo que enfrente el miedo → 21
Corinne J. Montes
El futuro de la disidencia → 25
Daniel Nudelman
El Durmiente del Valle → 33
Eliza Mizrahi, Juanpablo Avendaño y Edwin Culp
Recuerdo de Manzanillo → 36
Elisa Lavore
Rebeldía sin título → 38
Emiliano Urteaga
Toda conclusión es falsa (incluyendo ésta) → 42
Eugene Zapata
Ursula Lascurain → 49
Algunas palabras sobre el Zapatismo → 50
Fernanda Navarro
Francisco Barreiro a Francisco Barreiro sobre Joaquín Barreiro →
Francisco Barreiro Flores y Francisco Barreiro Romero
Necesidad de pensarte, de dialogarte, de tenerte → 60
Dr. Juan Manuel Sánchez
Netochka Nezvanova → 63
Julian Equihua
Santiago Solís → 66
Testimonio del que no se manchó las manos de sangre → 70
Luis Mario Moncada
Reflexión → 75
Matias Rodríguez Otero
Jose Luis Cuevas → 76
Incompetencia gubernamental en el sector agrario → 78
Rodrigo Ramírez
Colofón → 81
Rómulo Pardo
Cómo acostumbrarse a la violencia → 83
Santiago Ruiz
El derecho al Edén → 87
Txema Novelo
Andrés García → 92

El rumor del incendio → 95

bibliografía → 134

El rumor del momento

THE RIGHT TO EDEN
Essay by Txema Novelo

El Derecho al Edén

A medida que la máquina se perfecciona y quita el trabajo del hombre con una rapidez y una precisión constantemente crecientes, el obrero, en vez de prolongar su descanso en la misma proporción, redobla su actividad, como si quisiera rivalizar con la máquina (...) Y es precisamente cuando el hombre ha achicado su estómago y la máquina ha agrandado su productividad, que los economistas nos predican (...) la religión de la abstinencia y el dogma del trabajo.

Paul Lafargue

¿Quién inventó el arco y la flecha? ¿Aquellos hombres erguidos que en la desesperación y el hambre, tras el uso ineficaz de piedras, palos, patadas y mordidas llegaron finalmente a las herramientas? o ¿fue, más bien, la abstracción de aquel miembro del grupo que prefería estar cómodamente sentado bajo un árbol, observándolos, pensando?

Paul Lafargue, fue un revolucionario francés que pese a su joven convicción anarquista terminó por transformarse en un importante líder comunista, director de la Segunda Internacional tras conocer a Karl Marx y convertirse en un miembro de la familia al contraer matrimonio con su segunda hija. Después de una dedicada y aburrida vida política, Lafargue escribió su única obra: El derecho al ocio.

La premisa es simple pero contundente: si el obrero no tiene un derecho al tiempo libre, al descanso, al ocio, difícilmente tendrá la capacidad de sofisticarse en el plano laboral, si su jornada de trabajo es extenuante el hombre sólo vivirá para comer y para dormir, sin dedicar un tiempo esencial a la reflexión sobre su desempeño, sin preguntarse cómo podría hacer mejor su trabajo, mas eficiente, en menor tiempo. Lafargue pensaba en el ocio como el verdadero motor del desarrollo de la civilización, favoreciendo en la parábola del arco y la flecha a aquel "ocioso" del árbol.

THE RIGHT TO EDEN
by Txema Novelo

¿Who invented the bow and arrow? ¿Did those men who stood upright in despair and hunger, after the inefficient use of stones, sticks, bites and kicks finally reached for tools? ¿Or was it, rather, a product of the abstraction of one member who preferred to be comfortably seated under a tree, watching, thinking?

Paul Lafargue was a French revolutionary, who despite his young anarchist conviction eventually became an important communist leader, director of the Second International after meeting Karl Marx and converting into a member of the family when he married his second daughter. After a life dedicated to politics, Lafargue wrote his only book: The Right To Be Lazy.

The premise is simple but powerful: if the worker does not have the right to have free time, rest and leisure, it is unlikely that he will have the capability to become more sophisticated in both human and working context. If his workday is strenuous, man will only live to eat and sleep, and he will not spend essential time in reflecting on his performance, he will go on without wondering how could he do a better job, in a more efficient manner and in less time. Lafargue thought of leisure as the true engine for the development of civilization, favoring in the parable of the bow and arrow, that "idle being" below tree. Finally in 1911, at the age of 69, Lafargue and his wife committed suicide together in Havana, Cuba. It seems that they had waited too long for utopia to come.

Interestingly, the book does not grant the same 'power of leisure' to other aspects in the expression of human creativity (if work can ever be seen as such a thing). Nevertheless, the principle is the same when we consider the importance of leisure within the spectrum of arts, where this symbiosis is so deep-rooted that you cannot think of one without the other.

This is visible even within the educational role of mythology, in the origin of the Judeo-Christian morality. Cain and Abel, as the first heirs to the original sin, of corrupted man, would be the first ones to debut in the racetrack. While Cain represents the lineage of fallen man, Abel is the frantic last ditch effort between divinity and men, the last attempt of the God-Man.

When Cain decides to end with the life of his brother, jealous of his relationship with the Father, "God" decides to send away from his sight exiling him to the "World": to the structural representation of the socio-economic order of man that is imposed in our reality until this day, to that thing that Adam and Eve had supposedly conceived upon themselves, this world that we are supposedly condemn to. Cain founded a city far from the sight of the Almighty that was christened "Enoch", a place where man firstly began carving wood and building harps rather than trying to survive. The need for men to seek for God no longer laid in divinity, but in spiritual hunger, and such crave was satisfied by mean of the arts. Since his origins, man seeks God in the artistic practice, and the field of this search is leisure.

Our days are a materialized mix of the failed formal concerns of socialism versus the increasing triumph of right wing in the world, of capitalist alienation and of the economy of affection (which has led to the institutionalization of leisure in many ways). For me, perhaps the most interesting is the day-by-day growing entertainment industry represented today by videogames, that since 2001 its income exceeds those in the movie industry. Videogames transform contemplative leisure in an interactive experience that somehow imposes a new star system, curiously inspired in class struggle, which in turn suggests a strange image of corporative anarchism as outlined below.

Paul Lafargue would not live to know the case (or death by electric chair) of the Italian

anarchists martyrs Nicola Sacco and Bartolomeo Vanzetti in 1927. Although he, by partisanship differed from anarchism, maybe solidarity for the cause, the fact that both were being judged by uncommitted crimes or perhaps the memory of his early anarchist militancy would have sensitized him, just as this same case raised conscience around the world against one more of the atrocities committed by the United States on behalf of paranoia. This martyrdom found its first capitalization (or revindication) years later when a movie about the case was filmed (with horrible music by Joan Baez and Ennio Moriconne).

On the other hand, Sacco and Vanzetti would not live to see that in 1983, the Japanese company Nintendo would give life to their most important and successful franchise under the name of Mario Bros, created by the bohemian genius Shigeru Miyamoto (who hated computers and could only visualize his future playing guitar and traveling with a puppet show, the essence of minstrelsy). Forced by his father to have a "decent" job, he ended up in the Japanese company, conceptualizing abstractly about two Italian plumbers, that in order to earn their daily bread (in the form of score), would have to spend 24 hours a day cleaning pest a series of sewers.

It seems a joke to think that in the cosmic universe of the fantastic possibilities in the school of corporate characters, where anthropomorphic animals with unimaginable powers proliferate, it is the picture stolen from these two anarchist workers, paunchy and emulated from "Newsboy" cap to their pronounced mustache, that gives children endocrine narcosis and becomes the standard of an industry that makes profits in fascinating ways by means of the free time of individuals, with the so universal "game."

It is curious that the "struggle" is so whimsical, so endless, that it achieves being encrypted in the most unexpected places, just like a "Spirit" that survive generations by hiding, leaving us the archeological task of rediscovering it even in the most unlikely places.

The final explanation may be more demanding, because two years later -in1985 - the company went on sale with a Nietzschean version of the original Mario Bros, named SUPER MARIO BROS. In this new version, the two workers had left behind their crescent wrenches to enter a fantastic world of turtles and princesses, where money would not come from hard work, but would spill out of mysterious blocks by hitting them. The psilocybin of a striking local species of fungus would give superlative qualities to this pair of übermensch, which finally, under Lafargue's precepts, would gain historical justice by being able to live in a electronic version of revindication, and claim their much desired access to UTOPIA.

The conclusion of this idle idea of human sophistication from Lafargue, together with his revolutionary conviction, and the crucifixion and reincarnation of Sacco and Vanzetti as the Mario brothers, are the full parable of the redemption of a political struggle and social classes, that is mysteriously resolved in terms that might seem trivial, but it leaves in a massive way a hidden message of conscience and salvation to more than one generation of children (militants today), where you can play to work or eat from the sweat of your game while gaining direct access to the promised land.

If art is the inertial searching for God, of the fallen man, then leisure is its engine and there is a spiritual link that leads to the very origins of Eden, or what I like to call Spiritual Anarchy that parts from the basis of a world without the concept of a state, namely from a world without world. But It also recognizes that utopia is not an unknown place that we are trying to figure out, but it is the place that we have come from, for which we were created; to which we must return once we have accomplished our cleansing. And it is precisely in these terms that I can no longer differentiate between paradise and utopia, where progress (or regress) will not be conditioned by the struggle, but by our spirit and our ability to continue creating, to continue playing.

UTOPIA OR GAME OVER!!!

Txema Novelo, 2007.

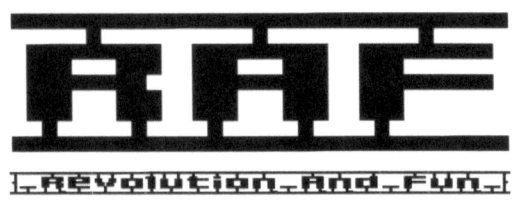

Txema Novelo
Mexico City 1982

He Graduated at the UNIVERSITY CENTER FOR FILM STUDIES (CUEC UNAM) for a degree in Film Direction, in Mexico City.
In 2002 he went to Vancouver for a full time course on Film Production at the Vancouver Film School (www.vfs.com).

His work has participated in the Third Public Art Forum of The SAPS in Mexico City, The Havana Biennale 03, The Image Festival of Toronto 2002, The Contemporary Art Fair MACO 04 and 06 in Mexico City, The Contemporary Art Fair of Spain ARCO 05 (During this year Mexico was the invited country) The VII International Call for Young Artists of the Luis Adelantado Gallery in Valencia, Spain. The FRIEZE 06 Art Fair in London, UK, The International Contemporary Film Festival of Mexico City 2007 & The Second SIVAM Visual Arts Contest in Mexico City &The Second Moscow Biennial of Young Art in 2010.

He obtained on 2004 the "Young Creators" Grant of the Mexican Savings Department to Promote Art and Culture (FONCA), in the New Media Division, and the 2006 "Arts & Media" Grant from the Mexican National Center of the Arts, CENART.

His Work has also exhibited individually in the Ramis Barquet Gallery, as well as in different collective shows in museums & galleries of Canada, U.S., Poland, Spain, Cuba, Argentina & Mexico, some of the highlight are: Art Museum Carrillo Gil, Mexico City, The Contemporary Art Museum of Poland, "Zamek Ujazdowski", The National Museum of Art "Reina Sofia" in Madrid Spain, The New Media Art Space "La Casa Encendida" also in Madrid Spain, The Art Space "Fundacion Telefonica" in Buenos Aires Argentina. He has also participated in projects of Net art with www.greylands.com and The Canadian Art collective Instant Coffee, www.instantcoffee.org.

He is an Artist for YAUTEPEC GALLERY in Mexico City (http://yau.com.mx)

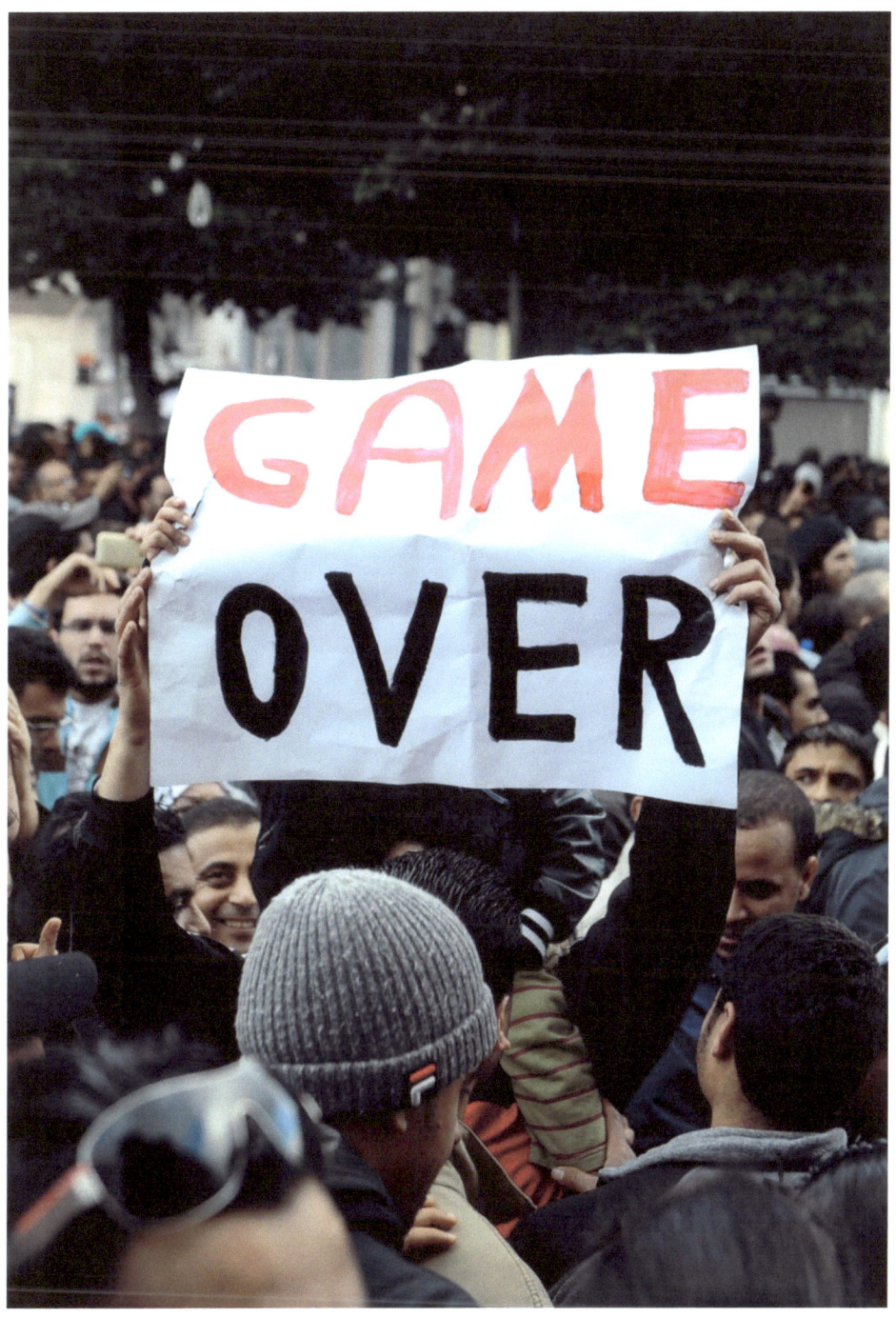

Demonstrator Placard Celebrating the end of the 23 years regime of Dictator Zine al-Abidine Ben Ali in Tunisia

January 15th 2010

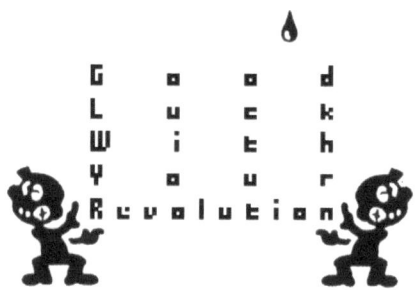

Inquires: info@you.com.mx
Artist Contact: txemanovelo@yahoo.com

www.ingramcontent.com/pod-product-compliance
Lightning Source LLC
Chambersburg PA
CBHW041108180526
45172CB00001B/165